PHANTASIA

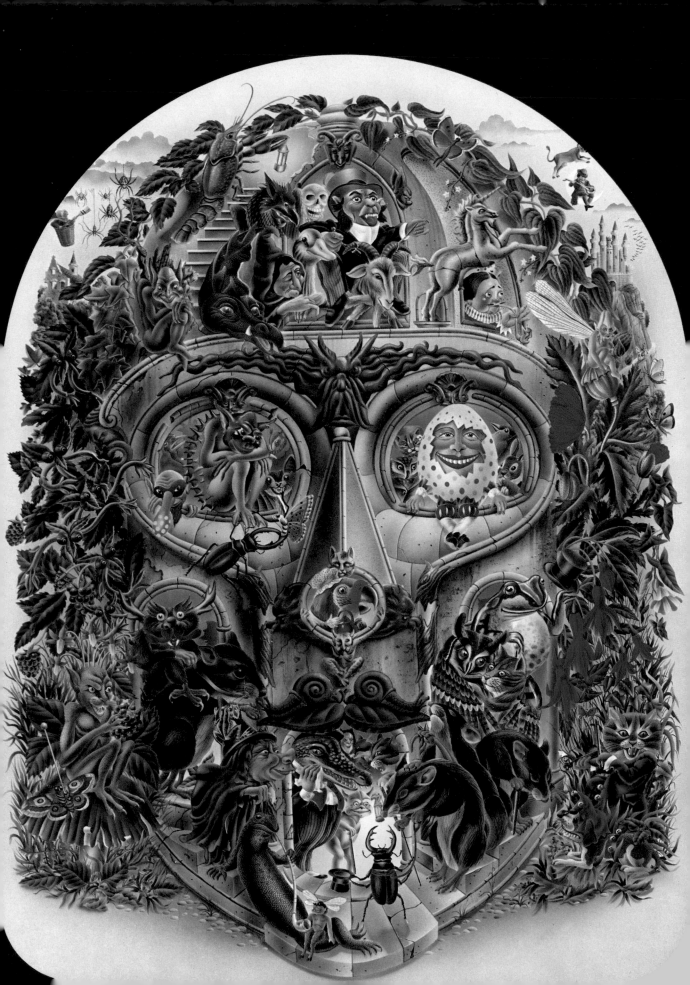

PHANTASIA
OF DOCKLAND, ROCKLAND AND DODOS

ALAN ALDRIDGE

ILLUSTRATED IN COLLABORATION WITH
HARRY WILLOCK

JONATHAN CAPE THIRTY BEDFORD SQUARE LONDON

Also illustrated by Alan Aldridge

THE BUTTERFLY BALL AND THE GRASSHOPPER'S FEAST
verses by William Plomer

THE SHIP'S CAT
verses by Richard Adams

THE PEACOCK PARTY
verses by George E. Ryder

THE LION'S CAVALCADE
poems by Ted Walker

ACKNOWLEDGMENTS

The author and publishers would like to thank the following for permission to
reproduce material: Mary Evans Picture Library for angels and moons, p.47; William
Heinemann Ltd for logo from the jacket of *The Beatles* by Hunter Davies (1968);
Penguin Books Ltd for the jackets of *Kiss Kiss* by Roald Dahl (1969) and *The Penguin
Book of Comics* by George Perry and Alan Aldridge (1971), (executed by Bob Smithers
to a design by Alan Aldridge); the Estate of the late George E. Ryder for his poem
'The Eagle'; the Society of Authors as the literary representative of the Estate of John
Masefield and Macmillan Publishing Co., Inc., for the extract from 'Cargoes', from
Poems by John Masefield (copyright © 1912 by Macmillan Publishing Co., Inc.,
renewed 1940 by John Masefield); and the *Sunday Times* for pp.10 (top) and 15. The
poem on p.45 is adapted from *The Worm Ouroboros* by E.R. Eddison
(Jonathan Cape, 1922).

Cover: *Artist as Goldfish Bowl, Tokyo exhibition, 1970;*
facing title-page: *Nursery Rhyme Self-portrait, Fitzwilliam Museum exhibition, 1973*

First published 1981
Copyright © 1981 by Aurelia Enterprises Limited

Jonathan Cape Ltd, 30 Bedford Square, London WC1

British Library Cataloguing in Publication Data

Aldridge, Alan
Phantasia.
I. Title
741.942 NC978.5A/

ISBN 0-224-01700-4

Printed in Italy by A. Mondadori Editore, Verona

Dedicated to
HIERONYMUS BOSCH, BASH STREET KIDS,
ALBRIGHT, DALI, CHIPS, PICASSO,
RAINBOW, GRANDVILLE, MICKEY MOUSE,
RUBENS, BOCKLIN, SUPERMAN,
YGGDRASIL and SAI BABA

'Only with the heart can one see rightly.
All that is essential is invisible to the eye.'

The Fox to the little Prince,
The Little Prince,
Antoine de Saint-Exupéry

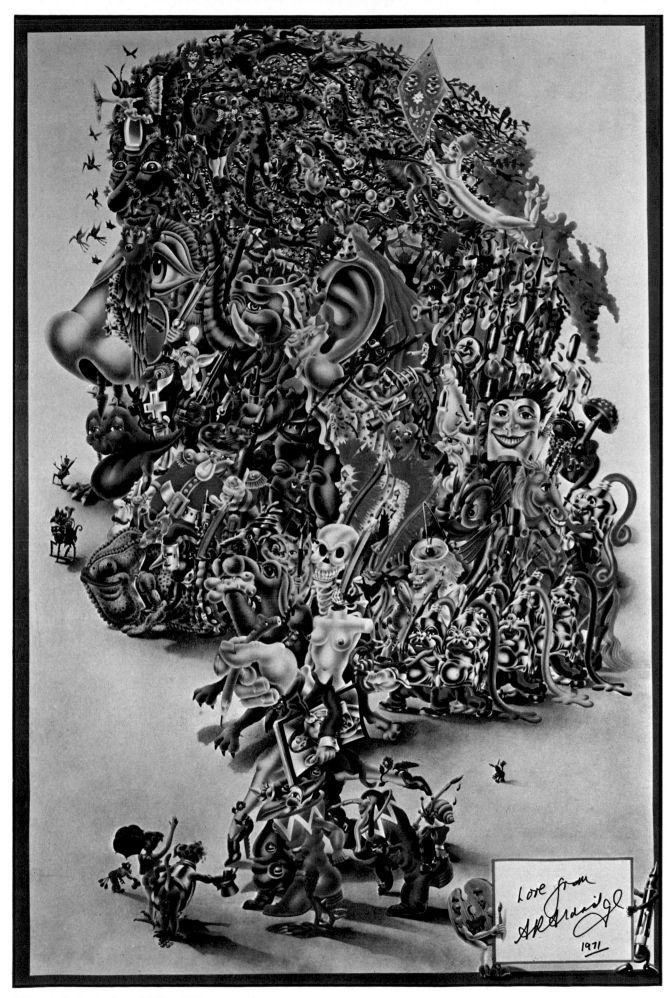

Self-portrait, Amsterdam exhibition, 1970

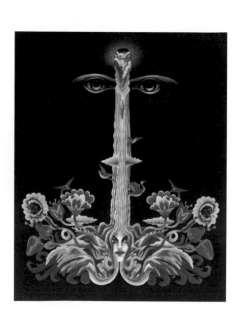

INTRODUCTION

O WHAT'S IT ALL ABOUT, this illustrating lark?
How come at twenty I'm down the East India Docks
Humping vast, cruel crates of Leyland motor spares,
Pig-lead and dynamoes on to cold grey ships,
Their rusty innards crying through broken seams,
Far flung from school and Masefield's *Cargoes*:

Quinquireme of Nineveh from distant Ophir,
Rowing home to haven in sunny Palestine,
With a cargo of ivory,
And apes and peacocks,
Sandalwood, cedarwood, and sweet white wine.

Masefield sparked me off at school and later Dylan Thomas
Was my god, my holy hero. After work my world
Was full of poetry and rejection slips.
I longed to whisper poems of dwarves, madmen, cockles,
Curlews and opium-eaters to sad-eyed Shebas,
To be the life and soul of the public bar
At the White Horse, Roman Road,
With a beer belly, fag dangling, spearpoint shirts
À la Alan Ladd and Dylan's dark brown-ale voice.
So how come fifteen years or centuries later
I'm a red-eyed, hunched hermit
Pushing H.B. lead across vast and endless
Wastes of white paper, making images,
Searching for the Holy Grail?
At twenty I'd never heard of graphic artists
Or illustrators (in Art Class at school
We did draw-ring and paintin, never illustrating!)
I wrote poems, a Bassett's Allsorts of Dylan and Auden,
Read them softly to factory girls with watery eyes
Up and down the City Road, in and out the Eagle,
Swam around the local snooker halls
Taking shillings from Billie the Limp,
Charlie the Gasman and Blind Bert,
Sat with the meths drinkers of Commercial Road
Around their blazing fruit-box bonfires
Listening to their tattered tales of the General Strike,
Tramping doss-houses, begging and booze,
And reckoned I admired them more

The Wind From Nowhere, Penguin Books, 1965

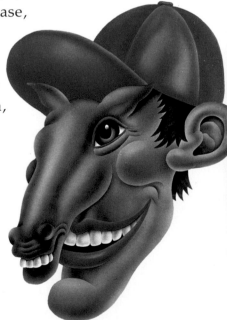

Than the flood of season-ticketed, tailored
Tick-tock types who poured in and out
Of Liverpool Street Station.
Saw the leathered rockers, the suburban wild ones,
Clerks, carpet-layers, clean-fingered nine-to-fivers
Beat blood and bone from the Mods
In Bilgori Italian bum-freezers and pointed feet
Outside the morbid grey canyons of Ilford Palais.
Watched the early sixties' fashions blossom at Barry's,
A Hackney dance emporium dedicated to self-aggrandizement
When mini-skirts, spade pants, snakeskin jackets
And shoes – pointed, round, chisel-toed, hand-made,
High-heeled shoes dictated East End fashion.
'Aris' (Aristotle) the Greek cobbler made beautiful shoes
From his little basement in Robert Street
With its smells of leather and strong cigarettes.
At whatever hour you went for a fitting
He was always grunting and groaning with
Some little piece of Turkish Delight deep amongst
The grey folds of his enormous bed.
So his shoes were a great investment for a young man:
You got a free sex education thrown in.
Next I discovered Corso, Ferlinghetti and Ginsberg,
On the Road was my Gospel According to St Jack.
And I left the Docks, moved to Earls Court
With rats and roaches in a one-room suitcase,
A broken water-heater, hot and cold
Running Pakistanis on the stairs.
Spent my days at Earls Court Station
Wide-eyed, begging pennies with a story
That I had to ring home to mum in Australia,
'Thank you, Guvnor. Thanks Mam.'
Or I went down the 'Dilly', chatting up Americans
For Camels and Marlboros to sell in Funland
Amusement Arcade in Tottenham Court Road:
Five for 3d. It's hungry, when you're at the bottom
Down among the dead men, you're
Always thinking and dreaming of food.
I lived off pilchards, herrings, sprats,
Anything that resided in a flat tin.
They were easier to 'borrow'! Sorry Mr Tesco,
You got your own back though
When I 'half-inched' a tin of anchovies.

Jockeys, Woman's Mirror, 1968

Above: *Ageing!*, Sunday Times, 1967

Nights were spent in Soho, 'up West',
Filled with drizzle, sleepwalkers, toms,
Saints, bogies, Chinamen, and landladies
Who never got their rent. Loners, loonies,
Jonahs, and music from broken windows.
At the Alibi I played conga drums all night,
Sweat dripped from the walls, the air was full
Of bombers reeking sweet of far-off Jamaica.
In the Nucleus, smelling of sour plimsolls,
Where dull grape-eyes watched the passing speed,
I played the drums to eat tired spaghetti
Heaped with dead rhino-skin, cold at five a.m.
So, what's all this to do with drawing?
Well, I'd been over Brick Lane
Singeing feathers from chickens
Still warm with life, in a halal butcher's,
4s an hour and all the livers you could eat.
Trudging up through rotting fruit and veg
To the Wheatsheaf Arms
Off Wentworth Street,
Everywhere cheap gramophone
Speakers belted out
'SHE LOVES YOU, YEAH, YEAH, YEAH.'
Stall-holders with red-veined eyes
Yelled it, flies buzzed it,
Worms rolled out of the pavement
And danced to it.
In the public at the Wheatsheaf
A Rock-ola surrounded by factory girls
Repetitioned it endlessly.
Something strange and magic
Was in the air:
It was THE BEATLES.
God, their white faces hung like
Crescent moons on the black L.P.
Cover. They're kids, my age –
But in this dark middle-aged era
Nobody does anything under thirty!
But here they were, John, Paul, Ringo, George,
Famous, pouring champagne over naked ladies,
Buying Mum a house in the country,

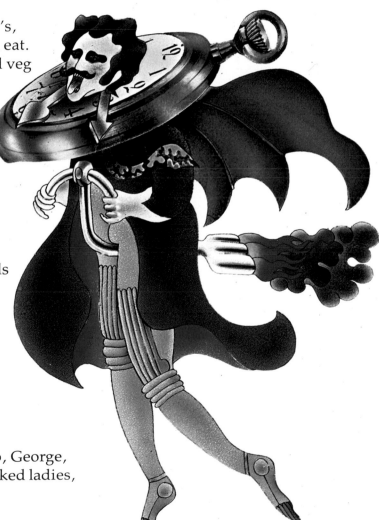

Time After Time, Penguin Books, 1964

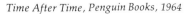

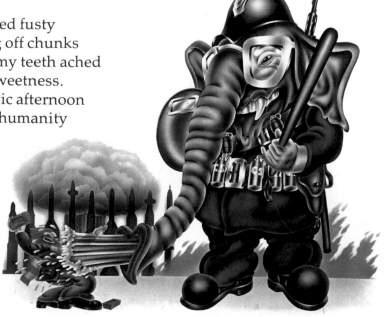

Waking up the Lion of England
From the knacker's yard.
And here's me, a chicken singe-er!!
What had I done? Nothing,
Unless you count eating
One cwt (112 lb) of demerara
Sugar in thirty days
As some kind of unique feat.
And that was back
When I was ten
With a Brylcreem quiff,
Playing around bomb-buildings
Where, in a damp, smoke-smelling
Basement I discovered a sack
Full, rock-hard and rotting,
Lying behind a charred, bubbled door.
Disregarding the rain,
Dogs, cats, navvies and tramps
That had watered it over the years
I tasted the concrete contents
And bless my soul,
Solid brown sugar!
Every day regularly, come rain
Or shine, after school
I'd be down that ruined fusty
Basement chipping off chunks
For hours, until my teeth ached
With the pain of sweetness.
Anyway, on this magic afternoon
In 1963 with the whole of humanity
Humming THE BEATLES
I went for coffee at a tiny
Bo-Bo place called Bunnies.
Whilst sipping the 'in' frothy drink
And wondering at my future prospects,
Also noting my shoes needed
A complete renewal of Sellotape,
I saw a tiny poster headlined:

Is the Law Two-faced?, Nova, 1967

How to Deal with a Riot!, Daily Telegraph, 1969

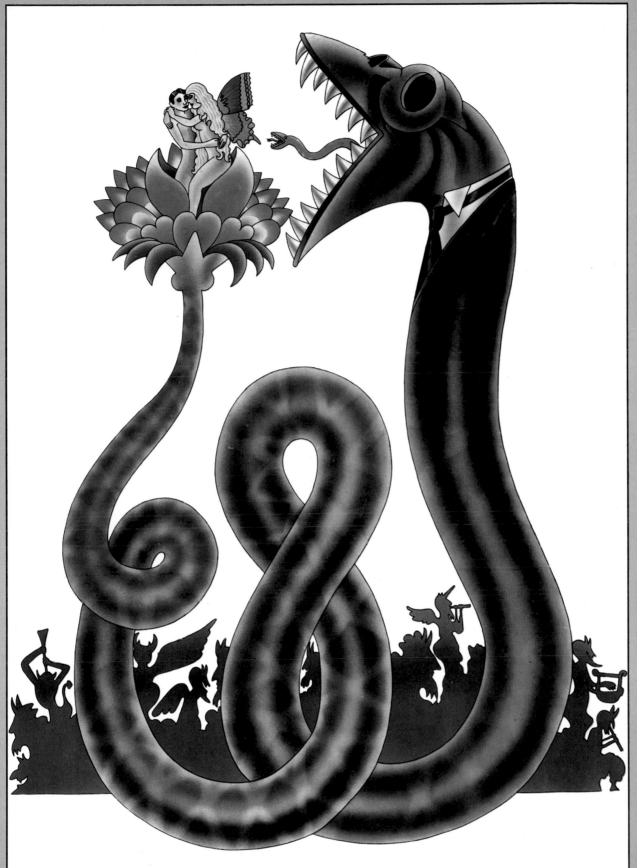

"**The Arts & Censorship**"

The National Council for Civil Liberties and *The Defence of Literature and The Arts Society*

Composing, writing, directing, performing: Larry Adler John Antrobus John Arden Dame Peggy Ashcroft

A Gala Evening concerning Depravity and Corruption Kevin Brownlow Cornelius Cardew Carl Davis

Samuel Beckett Edward Bond John Bowen Georgia Brown

Ronald Duncan Frankie Dymon Jnr. Tom Eastwood Andrew Faulds Fenella Fielding Richard Findlater William Gaskill Peter Gill The Grateful Dead

Sheila Hancock Stuart Hood Joseph Horovitz Ann Jellicoe Philip Jenkinson Paul Jones Bettina Jonic Christopher Logue Jonathan Lynn Charles Marowitz

Roger McGough & Scaffold George Melly Derek Mendel Adrian Mitchell Warren Mitchell George Mully Richard Neville Donald Ogden Stewart John Peel

Geoffrey Reeves William Rushton Maxwell Shaw Johnny Speight Fritz Spiegl Crea Tarrant John Tilbury Rita Tushingham

Billie Whitelaw Nicol Williamson **Royal Festival Hall** Charles Wood Etc. Etc. Etc.

General Manager, John Denison, C.B.E.

8pm. Monday, 9th December, 1968 Designed by Alan Aldridge Ink Studios

FREE COFFEE
Graphic Workshop commences on Feb. 15th, 1963.
A 10-week course of one evening per week, 6–9.30 p.m.
Discussions by
GERMANÖ FACETTI, BOB GILL,
ROMEK MARBER, LOU KLEIN, etc.
£10 for complete course
Apply to such and such address
at such and such a time with
PORTFOLIO

Then it had a most interesting P.S.

If you've got no money and we like your work,
come along anyway, you'll get the course and
the coffee FREE

Now the mention of a workshop
Made me think it might be something
To do with the theatre, as all the world
Knows about the Theatre Workshop
At Stratford in London's East End.
And I attended the opening night
Of the Graphic Workshop, having no idea
What graphic meant, except that as a boy
I'd delivered a newspaper called the *Daily Graphic*.
 The crowd there was very smooth:
 Three-button suits and button-down
 Brains. I sat at the back of the class.
 Lo and behold at the interval
 They served free coffee – well, Nescafé.
 The Workshop was run by top dogs
 In the advertising, design and TV industries.
 After ten weeks I knew Saul Bass wasn't a fish,
 Bodoni was a typeface and not a Mafia hit-man.
 Venus Extra Bold wasn't
 A pornographic Botticelli.
 To boot I also won £25 for a cover design
 I'd done in class for PENGUIN BOOKS
 And so began the 'bum's rush' up the
 Woodwormed 'ladder of success'.

The Automata, 1965

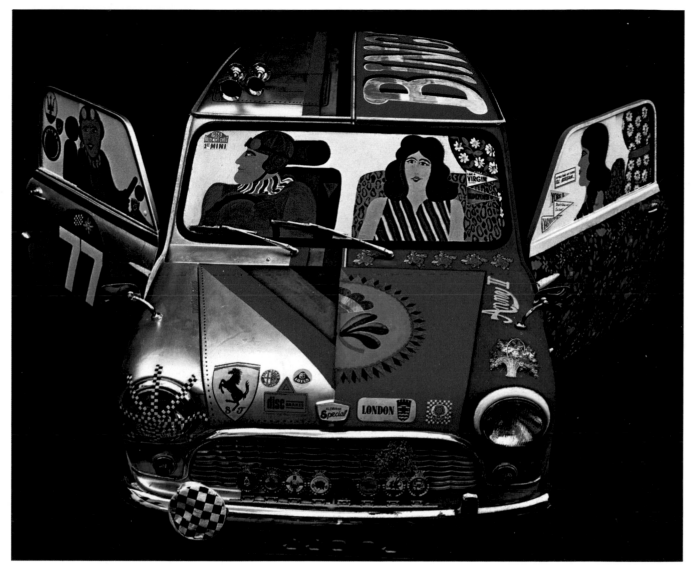

Automania, Sunday Times Magazine, *1965*

No more sad cafés with maggots
In the cold pork, or reboiled tea
With waitresses dying of something awful!
No more grey-haired landladies
With keyholes sewn to their icy eyes.
No more cheap dreams on dosshouse
Mattresses with brown and red bugs that don't
Go away. Now, simply by drawing, my pockets
Filled with £5 notes. Now I wanted potted
Plants, ferns, and a twenty-year mortgage,
To sit in Soho, with odd socks,
And eat rigatoni bolognese.

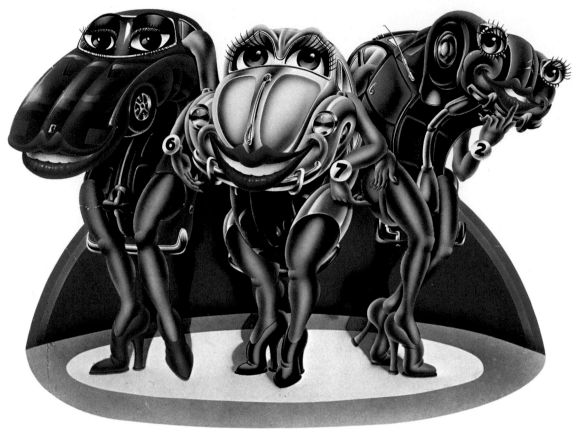

Car Cosmetics, Stern *magazine, 1969*

On Sundays, colour-magazine millions
With marmalade fingers saw my work,
Laughed at it, or loathed it.
I decorated old refrigerators,
Made Plasticine models,
Painted upon pretty naked ladies and mini cars
All to hide my want of skill at drawing.
But people started whispering 'genius',
Newspapers yelled, 'Beardsley in blue jeans',
Women's magazines phoned
Asking what aftershave I wore,
Did I sleep in pyjamas,
Would I go with a club-footed woman?
Fame creeps up on you
Like the Invisible Man with a hatchet!
At twenty-three I was appointed Art Director
Of Penguin Books – £2,000 a year
And all the Simenon I could eat.

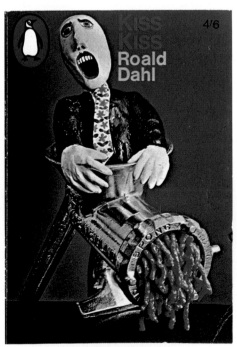

Kiss Kiss, Penguin Books, 1969
The Penguin Book of Comics, 1971

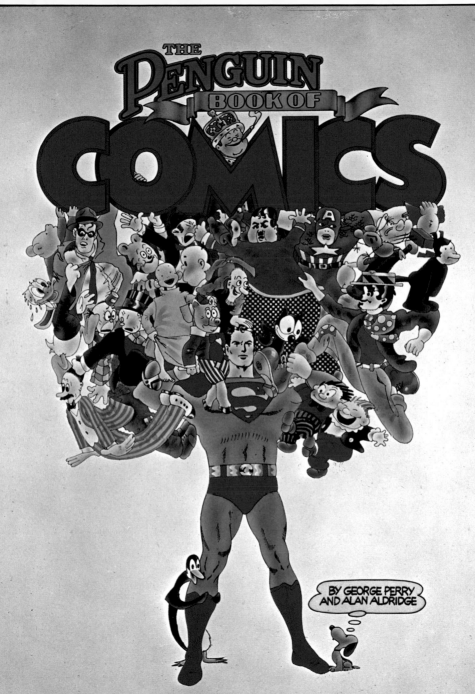

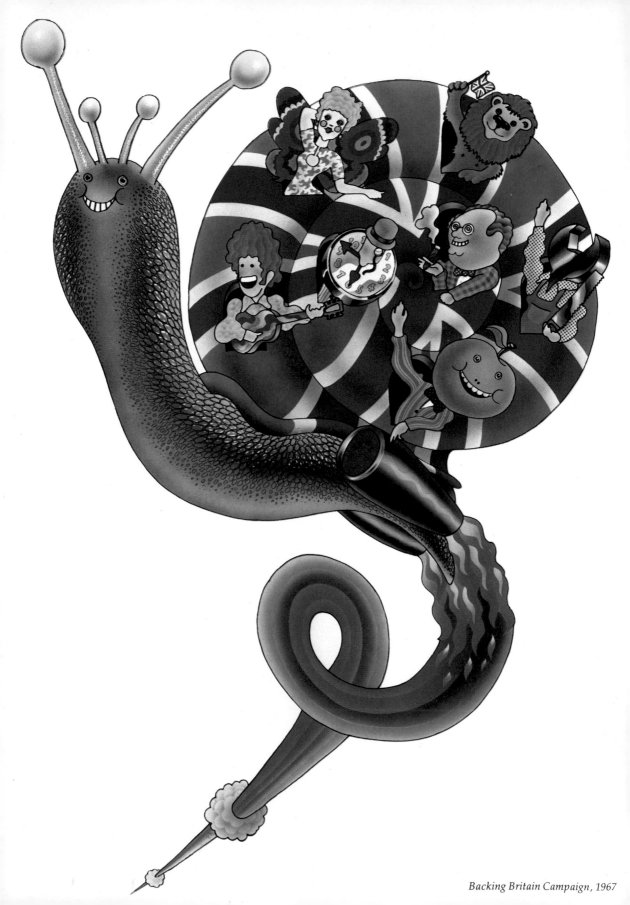

Backing Britain Campaign, 1967

Taxis, expense accounts, my own office,
Problems: covers with naked tits
Sent the sales up but upset the authors.
Anthony Powell wrote me a nasty letter!
Penguin big-wigs hatched plots to roll my head
So I left, and set up my own studio
Called INK. Three floors of total madness,
Incense and rickety pinball. My buddies
From Penguin and the *Sunday Times*,
Harry, Bob and Dick, joined me.
We played football with rolled paper
In the empty rooms, until the phones
Were installed, after which bells
Never stopped ringing: Procul Harem,
The Stones, Pink Floyd, Family, Cream,
Nova, *Vogue*, *Harper's*, *Queen* – aaaaahh.

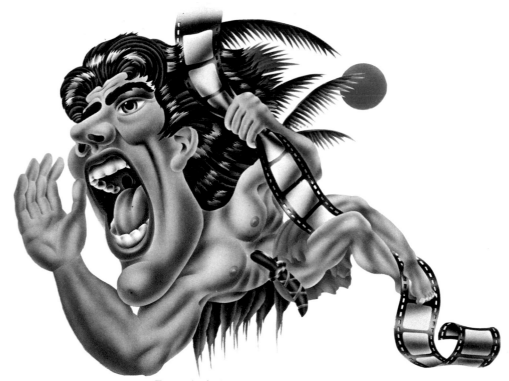

Tarzan in the Movies, Observer, 1969

And then I became Visual Consultant
To Apple, and their exalted majesties,
 THE BEATLES!

THE BEATLES

As a kid life was a sour-milk sea of DDT flyspray,
 Brylcreem, mothballs, Brasso, stale cigarette smoke,
 Fingernails filled with Kiwi boot polish, chapped legs,
 Piles of A-Bombs, Victor Sylvester muzak –
Droning endlessly from huge, glass-valved, Bakelite radios.
Frankie Lane, distant – remote – American,
Fifteen years on nothing much had changed,
Brylcreem, mothballs, Brasso, stale cigarette smoke,
Jack Webb on 'Dragnet' viewed through a continual
Snowstorm on the second-hand goggle box,
Boring jobs, clerking, lifting, digging, delivering,
Worrying, that was new! About death, pensions,
Pawnbrokers, 'bovver' paying the rent, buying winkle-pickers!
There were hula-hoops, square dances, piles of H-bombs,
And Frankie Lane was still distant – remote – American!
Then came the Beatles, just kids – BRITISH!
Washed the Brylcreem 'right outta my hair!'
Now I could be in with a chance – to do what?
A big ladder dropped down from the clouds.
I began to climb.
The Beatles, dream-weavers of the mythic sixties,
Became a major influence on my life and part of
My early career, apart from creating and editing
The Beatles' Illustrated Lyrics books.
After meeting John and Derek Taylor
At the Arethusa in 1968,
I was designated 'Royal Master of Images
To Their Majesties, The Beatles',
Working for the Mad Apple
For over two years, watching
Its sad, frantic disintegration.
It all began in 1966.
I'd stepped off the ladder
To become the Art Director
Of prestigious Penguin Books

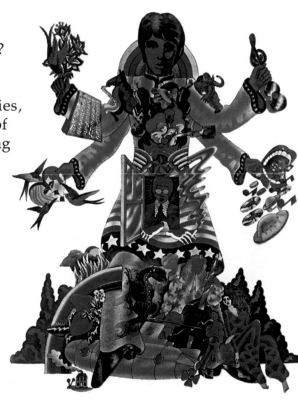

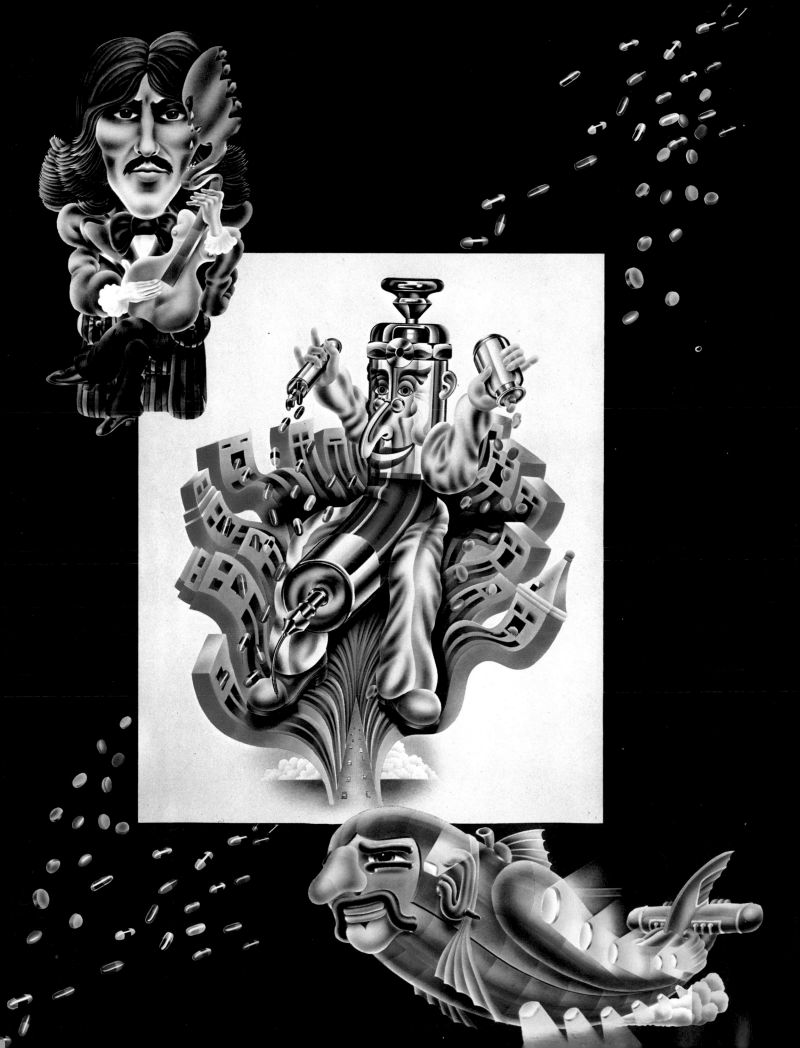

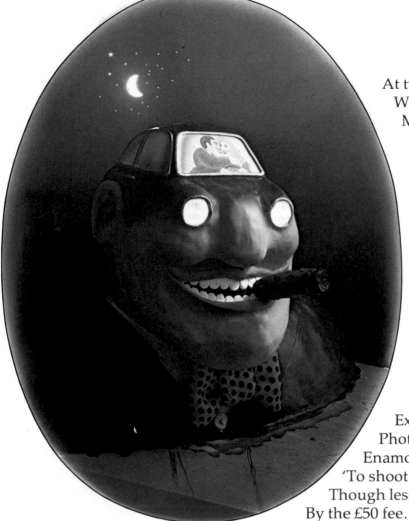

At twenty-three,
Which caused a few
Monocles to drop
Amongst the 'London
Graphic establishment'.
I was organizing a cover for
The Penguin John Lennon,
A compilation of his two hugely
Successful and funny books,
In His Own Write and
A Spaniard in the Works.
After a little politicking
With Brian Epstein,
I got the news that
John had agreed
To sit for a portrait.
We arranged to meet at Duffy's,
Very 'in' (East End obligatory),
Excellent but expensive
Photographer who was
Enamoured of the opportunity
'To shoot yer actual Beatle'
Though less overawed
By the £50 fee.
An hour after John was due
Duffy's mood was getting very black –
'Fucking lazy pop-stars!'
After two and a half hours, I was in the corner
Desperately trying to disappear up my own . . . !!
Three hours late, he breezed in, quipping,
'Hope you don't mind, I brought a friend along,
You might know him.'
Through the door came a nose, followed
By the saddest eyes in show-biz, Ringo.
Nobody mentioned their being late, they were Beatles,
This was London, they were royalty.
John continued, 'We were in the Limo,
Fancied a cuppa tea, drove round for ages
Trying to find a place we wouldn't get mobbed.

Above: *Baby You Can Drive My Car, 1966*
Opposite: *Ringo – Mr Kite, 1968*

Finally we hopped over to the Ritz! Sorry!'
Why it didn't occur to them that Duffy would have
Been delighted to make tea, I don't know.
I remember thinking if fame means not
Being able to wander into a café for a cuppa
Then forget it!
For the session I'd made models in Plasticine
Of characters from the books,
Painted mad eyes on granny spectacles, tailored up
A John Lennon 'Superman' outfit –
For a couple of hours he posed with enthusiasm
Then abruptly, 'Gotta go!', combed hair,
Rushed back into the Rolls with Ringo.

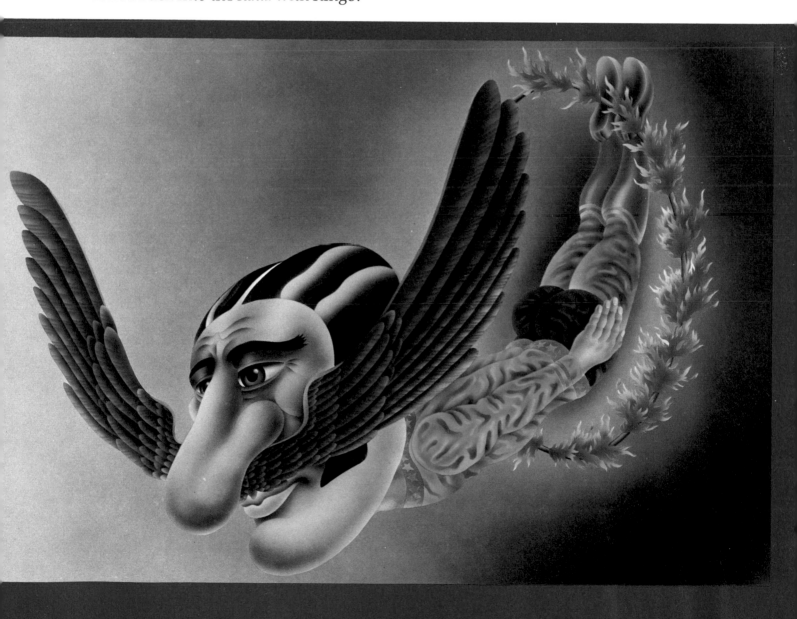

The black symbol slunk off into traffic
Seeking new city thrills.
Two days later, much to my surprise,
John rang and thanked me
For all the effort I'd put into the session.
Sometime later in 1965,
After Harry Willock and I
Had discovered the airbrush
For illustration and become
The 'darlings' of all London magazines,
I was doing a spread on the Beatles
For *Woman's Mirror*, in which John
Appeared as a quack, christened
Dr Robert, the inside of his coat
Filled with bloody organs
Ready and waiting for a rich customer.
Sadly the magazine banned it
But I sent a print of the original to John
Knowing he would enjoy the macabre portrait.
At the Revolution – dark, trendy,
Guaranteeing pop stars anonymity,
John and I drank Bacardi with Coke,
And he described how in America
Touring English rock bands
Could be supplied ad Librium
With any drugs necessary to keep
Them rocking and happy.
The evening blurred, we talked of Tolkien,
Alice in Wonderland, The Apocalypse, Picasso.
Someone gave us some Mexican honey,
Apparently the bees had been put to work
On the pollen of flowering cannabis plants –
Whatever, the room went elastic, my head
Shot up to the ceiling, draped over the chandelier,
My legs ran off down Berkeley Square – John melted.
Some years later when I was putting the
Beatles' Illustrated Lyrics together I remembered
John's story and did a new version of John as Dr Robert
Sat atop Manhattan throwing amphetamines, LSD,
Quaaludes, amyl nitrate, uppers, downers, yellow subs
Down into the street below, turning the whole city on.
Like its predecessor it was banned!

Above: *You're Tearing Me Apart, 1968*
Opposite: *Helter Skelter, 1968*

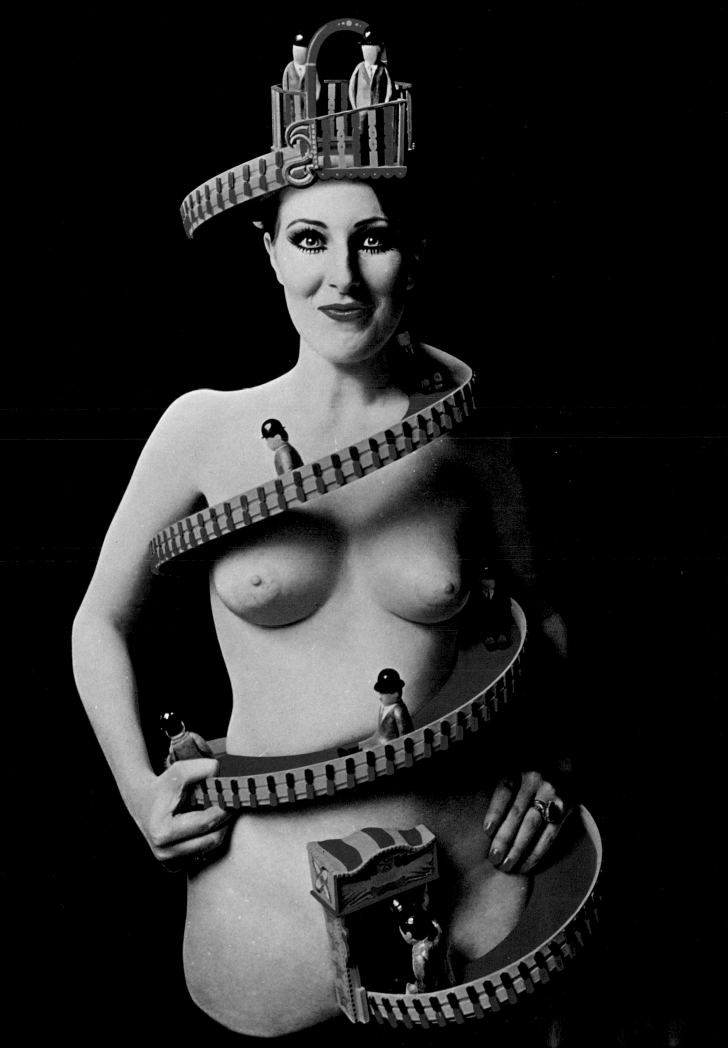

Another time he and Yoko had an exhibition
Of work at the Robert Fraser Gallery in Mayfair.
The press view was 3 o'clock,
The invitation card read 'Drinks'. Now after 3 p.m.
Is dry time in London, the pubs have closed,
So hordes of reporters and photographers arrived
At the show, looking for free liquid sustenance to take
Them through until the pubs re-opened at 5.30 p.m. –
They were not amused to find only Schweppes's Malvern Water
 At the gallery's bar!
 The Beatles broke up,
 Everyone went separate paths.
 During the sad seventies
 I met John on a few occasions,
 Always had a laugh,
 Whether in smoggy L.A.
 Or dying London.
 Then on December 10th, 1980,
 Working in L.A. late one night,
 I heard of John's stupid
 And tragic death.
 Along with the tears, a thousand
 Happy and private memories –
 John was 'the guvnor'.

Above: *Cry Baby Cry, 1968*
Opposite: *Sexy Sadie, 1968*

'I never wanted to be a household
name. I'd rather remain faceless.'
 JOHN LENNON

THE ROLLING STONES

THE ROLLING STONES' office called up
And invited me to join Mick and
Keith to view a rough cut of a new
Movie they'd put together. We all
Met up at a real cheapo
Viewing theatre off Charing Cross Road.
The movie began to roll . . .
Titles flickered, then

THE ROLLING STONES ROCK AND ROLL CIRCUS
. . . 5 . . . 4 . . . 3 . . . 2 . . . 1 . . . Bang – the P.A. system leapt
Off the wall as The Who decimated 'Boris the Spider',
Dwarves and freaks menaced in the background,
C/U Marianne Faithfull. The P.A. system was only just
Holding together when Taj Mahal took over
And drove the decibels on. All 1s 9d seats were definitely
Dancing. Tigers, lions, the ring master leers . . . fade . . .
C/U new group, Dirty Mack (John Lennon fronting
With Eric Clapton, would you believe!)
Weave intricate licks around Yoko's screams . . . wipe . . .
And the grand finale: Their Satanic Majesties
Belt into 'Jumping Jack Flash', 'Sympathy for the Devil',
'Street-fighting Man' – 'The End' flicks up and is gone.
Silence. Speakers and ears fizz and crackle.
Though I showed Mick some drawings,
Produced a poster –
And got paid –
The movie disappeared for ever.

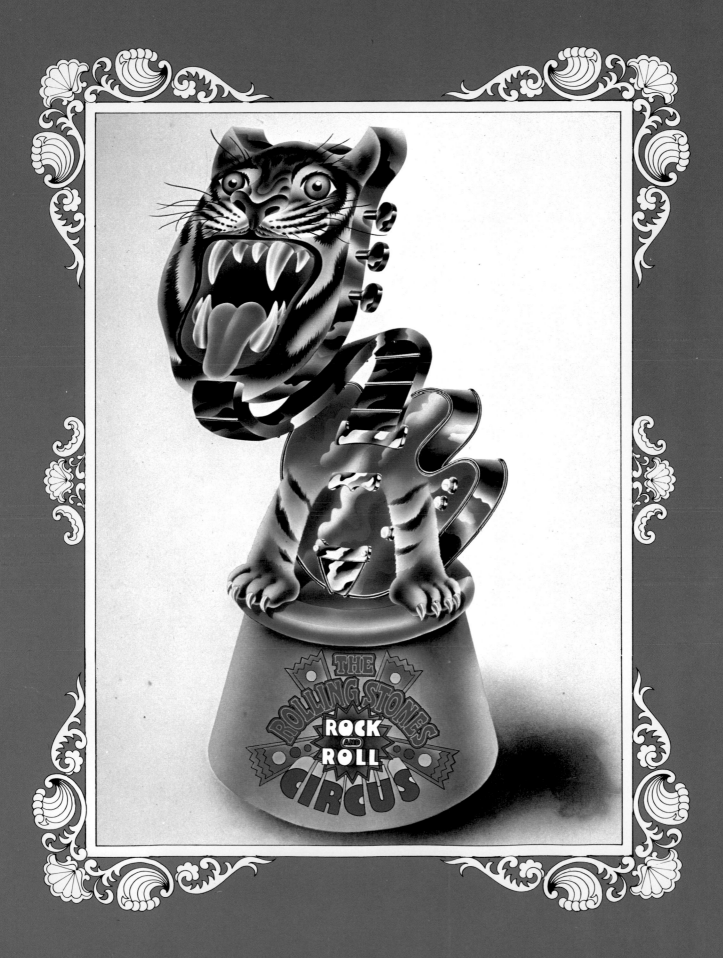

THE GREAT AMERICAN DISASTER

AFTER THE spaghetti-filled swinging sixties
The seventies heralded an American
Fast-food invasion!
London came under heavy bombardment
On all tablecloths from flying hamburgers.
The air was thick with gaseous smells
Of char-broiling and dill pickles.
The citizenry, once allowed time and
Peace to digest meals,
Were ejected from fancily named burger joints
Bloodied with tomato ketchup, dribbling
Half-chewed french fries and Michelob –
Collapsing up and down the King's Road
Into chicken-boned gutters, eyes rolling,
Bellies bloated with starch-filled rolls
And 100 per cent dead beef patties.
Their cheeks concaved from trying to
Suck thick glutinous milk shakes
Through 18-inch multi-coloured straws!!
All good clean fun – the first and best
Of London's new U.S. gastronomy was
Peter Morton's Great American Disaster.
Those who tried to copy its excellence
Were responsible for the burger nightmares
That stalked through the seventies!

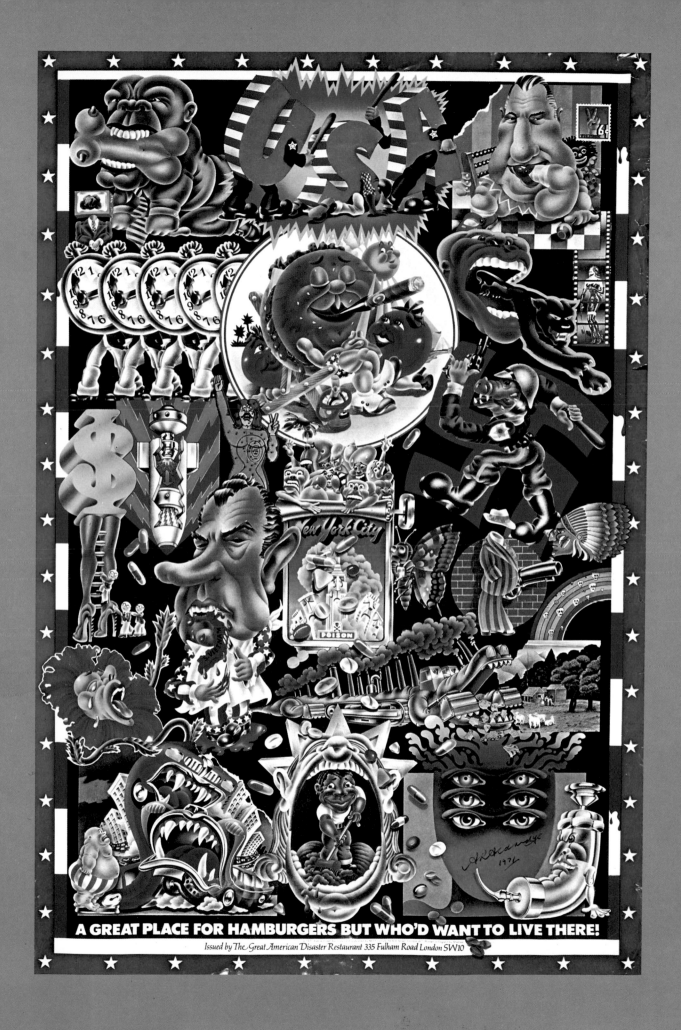

HOLLAND POP FESTIVAL

These were the final heady days
Of 'Flower Power', beads, hippies,
Good 'speed', the dawn of macrobiotics,
Sufis, joss sticks and straight lysergic,
Of children with names like Sky,
Rainbow, Dewdrop and Saffron.
Days of Panama gold and pigs,
Carnaby Street and Zap Comics,
But above all, long, long hair –
Hair pigtailed, ribboned with bells,
Enwrought with daisies, hair
Fusted with the smell of hash,
Afro'd, frizzed, permed, blow-waved,
Hair in ringlets, greasy, tangled, dyed,
 Lacquered – everyone was bent double
 Under the weight of vast rivers
 Of hair that poured for ever
 Endlessly from every minute
 Hole in their heads.
 The last days too of the huge Pop Festival
 That had blossomed into Woodstock and Monterey
 And died with the Stones at Altmont,
 Among mud, Karma and collective consciences
 The tulips sing their praises.

THE BYRDS	PENTANGLE
CARAVAN	PINK FLOYD
THIRD EAR BAND	QUINTESSENCE
INCREDIBLE STRING BAND	RENAISSANCE
FAMILY	SANTANA
TYRANNOSAURUS REX	SOFT MACHINE
JEFFERSON AIRPLANE	CHICAGO ART FESTIVAL
JOHN SURMAN	EAST OF EDEN

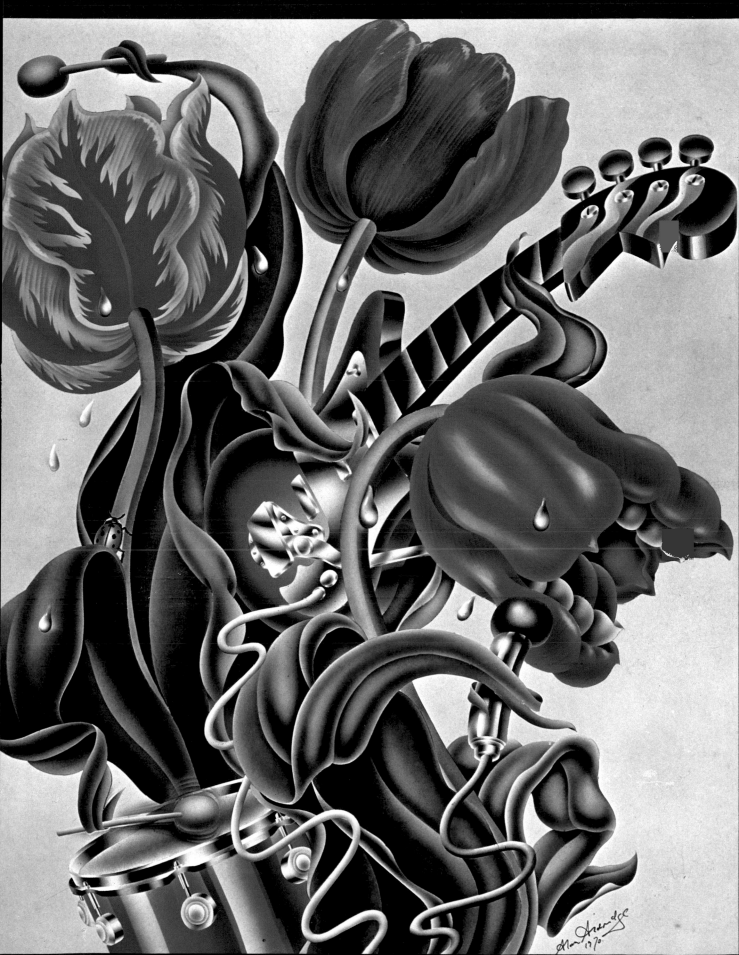

Chelsea Girls

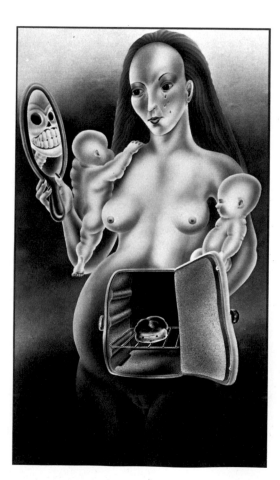

Vagina Rex *film poster, 1969*

The Arts Laboratory
Was a sanctuary, a kind of 'dropouts''
Social club for those who were
Tired of 'trattorias', boutiques,
Union Jacks, Vidal Sassoon, Herman's
Hermits, David Frost and Watney's Red.
Any old time at the 'Lab' you could
Meet a genius (chess or crossword!),
Lady mud-wrestlers, parachute-jumpers
Who'd lost their nerve, Crowley freaks
– evil, black inverted crosses
Tattooed between empty eyes –
And washed-up surgeons,
Eat spinach (remember Popeye),
Beans that had never seen a tin can!
And bread pudding soggy with raisins,
Dates and nutmeg, guaranteed to
Block the colon for many
A painful hour. You could see
Nazi storm-troopers,
Stroppy yellow men dying of opium,
Waitresses dazed by Wimpy neon,
Dossers decayed on British sherry,
Humped-back hippies, bent with
The weight of beads, chains and mortgages,
Beatniks all beards, berets,
Constipation and the *I Ching*.
Films were magicked in darkness
Flickering on to paint-peeling walls
Dean, Brando, gods with lepered faces.
Warhol's *Chelsea Girls* got premièred.
I did the poster, but no 'decent'
Printer would touch it – obscene they said!
A 'backstreet' printer came to the rescue,
Police threatened prosecution if it was
Publicly displayed, the fly-stickers
Were harassed – could all this
Be happening in liberated,
Swinging London – you bet!

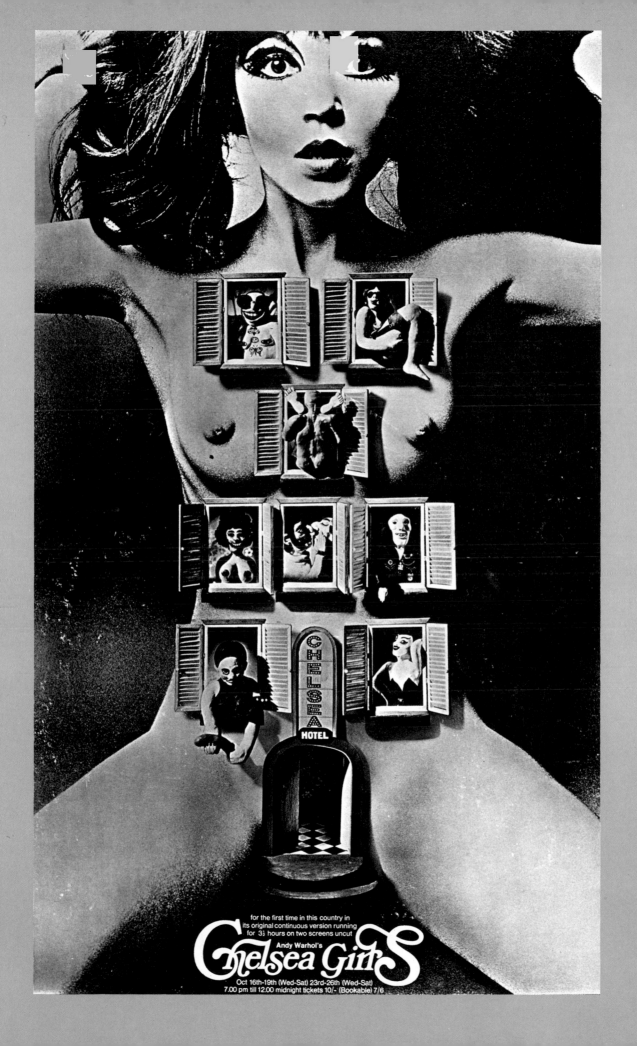

The limelights blinked to black,
'The Swinging Sixties' melodrama
Had played to packed crowds for six years
At 'Theatre of the Absurd', I saw
The once-bright, psychedelic curtain,
Now in tatters and cobwebs, draw closed.
The audience, doped, bored, staggered off
Hoping for new lunacies.
Performers paid dearly.
The Beatles split, law suits flying.
The Stones wallowed in
Black magic and Satanism.
Dylan viewed the snakes down the pit
And split to become a religious recluse.
Cream parted spitting, Clapton gave up guitar heroics for something harder.
Hendrix, Joplin, Brian Jones and Jim Morrison left before the last act.
Domesday shadows of atomic subs, B-52s, robots, Vietnam and
The Hydrogen Holocaust menaced darkly in the Gods.
Bit players and rat-racers were left to bounce around bed-sits,
Brains blackened and burnt, in a burlesque of reality.
Others grabbed gurus, Hare Krishna, Meh Baba, the Maharishi,
Madam Blavatsky, the Rev. Moon, Tiny Tim
Disappeared into Tolkien's mystical pastures for spiritual solace.
In the wings I mixed adrenalin with magenta, lavender and chlorine blue,
Cranking out day-glo ephemera faster than a coked-up Picasso
Among monetary mayhem, bad debts, tax demands, manic depressives,
Witches, warlocks, Apple, Stern, The Who. And when my overdraft rocketed
A rheumy bank manager dropped his smiling mask
Revealing a misered sauron in deep decay, ready to sell
Children, loot houses, auction 'loved ones' to slave traders, and
Mortgage my soul 'to redeem the a/c into black'!
Sorcerers prophesied the ugly seventies.
Glitter Rock, androgynous tarts perched on luminous high heels,
Skin clogged with powder, pub rock, and Disco,
'Prole' muzak were on the way.
It was time to call it a day.
I wanted to be the new Beatrix Potter blissfully at work in the calm countryside.
Among the misty vales of Norwich, I found a 'retreat', an old rectory,
Georgian, rambling, wrapped secretively in a shawl of black trees.
Now to become obsolete, enigmatic, study mycology, *Parsifal* and new trends
In clerical gowns, wear Gladstone collars, Oxford bags and
Weighty Norfolk jackets, write with quill pens, smell of moth-balls;

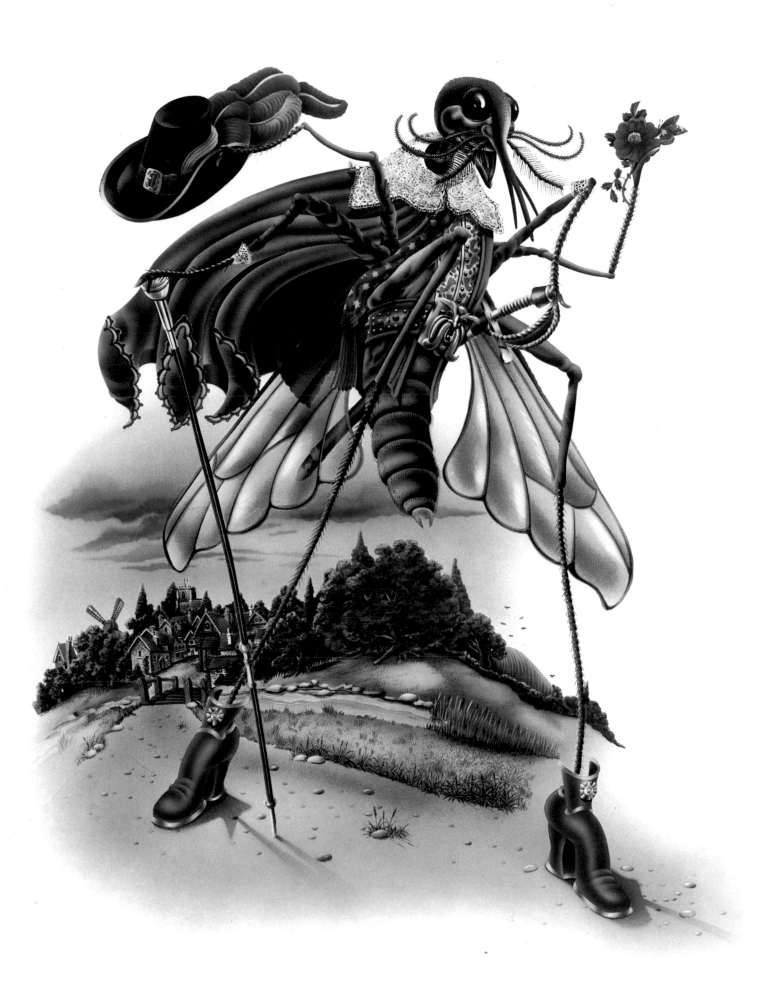

Meditate on the nocturnes of Chopin
Or Vermeer's *The Lacemakers*;
Buy ancient leather-bound books
On Phoenixology, Gigantism,
The Art of Farting by Count Trumpett,
And *The Use of the Cat-o'-Nine-Tails*
in the British Parliamentary System,
Daltonism, Nyctalopia, Phantoms,
Freudianism, Gestalt Theory and *Tit-bits*.
Ruminate on the pictures of Arthur
Rackham, with Earl Grey Tea,
Buttered toast, a cavorting log fire
For company. Paint magic images,
Seen through the eye
Flowing out from the brush,
Rhinoceroses, space monkeys,
Crucifixions, machine guns,
Gorgons, Gollums, centaurs,
Rotten pomegranates – bliss:
No more clients, products,
No hyperbole or parties, flirty typists,
Alvin Stardust, spongers, accountants,
No phones or whining business partners,
Only the grandfather clock
To tick me off in my twenty-eighth year!
But months of summer silence cracked my sanity.
Delusions, like rhesus monkeys, chattered in my mind,
Puffballs, big as barrage balloons took over
The library and morning-room, bindweed
Slid through every window nook looking to smother me.
Evening winds sharp with winter's ice-cold blades
Knifed through every ill-fitting window-frame
Of the old house. With no central heating,
I'd humped bed and books to the kitchen
Where the friendly Aga throbbed
And chuckled with comforting warmth.
On September 28th, 1971, I remember well,
Supper was courtesy of the local fish and chip shop,
'Cod and tenpenuff' cocooned in grease-blotched
Newspaper. Unwrapping my piping meal,
The name TENNIEL caught my eye
Among the grey blocks of busy newsprint.

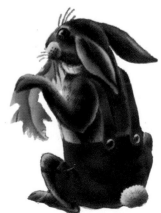

Flattening out the *Observer* I read an intriguing tale:
Sir John Tenniel, famed Victorian satirical illustrator for *Punch*,
Had created his finest work for *Alice in Wonderland*.
However, his collaboration with Lewis Carroll turned sour,
Tenniel finding Carroll's pedagogic fussiness beyond
His tolerance. Two years later when *Alice through the Looking Glass*
Was written, Carroll began to pester Tenniel for illustrations.
Finally the illustrator relented, but his terms included
'An embargo on any interference by the author in the execution
Of the drawings and their printing'. In Chapter One he found
Alice encountering a large wasp dressed in judicial finery.
After many efforts to illustrate this image he wrote to Carroll,
'A wasp in a wig is altogether beyond the application of art.'
The author responded in a rare act of creative piety
And cut the whole offending chapter from the text.
Tomorrow I would attempt
To draw a 'wasp in a wig'.
For me there's nothing
more creatively agreeable
than on a brand-new day
to sit at my desk,
overlooking the
skeletal orchard,
a clean drawing pad,
a sharp H.B. pencil,
the expectation
and excitement
of a strange and
magical journey
about to begin.
Starting the wasp,
the familiar jam-jar
bandit with
monstrous eyes
and awkward
triangular face,
I made many mistakes.
Slowly, mystically,
as the eraser fought
to correct errors, the
wasp metamorphosized
into a gnat,
with spindly legs,

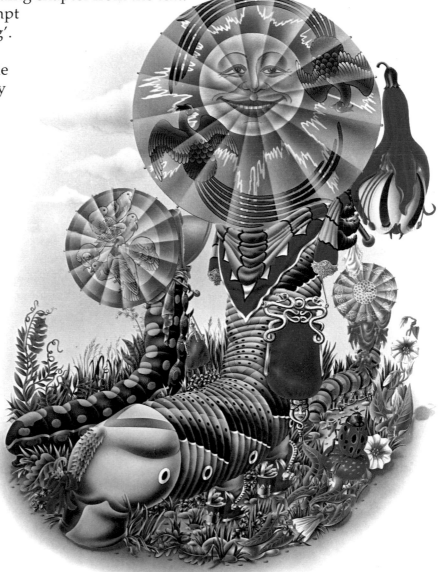

Fine feathered hat, high-heeled boots and cavalier cape,
And Cley, a local Norfolk village, filled the background.
A week later, I chugged down to Rye by dirty Southern Region,
And in the famed Mermaid Tavern, as I quietly sketched,
A bleary-eyed Scotsman staggered through the entrance doors
Collapsing rubbery at the well-oiled bar,
'Och, jeez I wuz pissed as a newt last night!'
Immediately I had this surreal vision of the bar
Filled with newts, palmate, crested and common, lurching,
Singing and spewing, under the 'affluence of inchohol'.
I had my second picture, but what sort of book was on the way?
At the British Museum, I scavenged through hundreds of dusty,
Bone-dry Victorian childrens' books, like an old, anxious
Detective searching for a literary peg to hang my drawings on,
And found *The Butterfly Ball and the Grasshopper's Feast* written by
William Roscoe in 1807, a tale of woodland creatures
Attending a Feast and Ball beneath the Broad Oak Tree.
It was exactly what I was looking for!
Over the next year my studio became choked with books
On mandibles, mosquitoes, dormice, dung flies, otters,
Moses Harris's *British Entomology* (1778), and the weirdest of all,
Blackwell's *History of British Spiders* (1827), with its eight-eyed pages.
Frogs, toads, bats and lizards accumulated, pickled in formaldehyde.
I crept around the garden like a star commando, snaring ladybirds,
Centipedes, snails and hornets. Finally twenty-eight plates were completed.
Now I had to reverse the process of Carroll and Tenniel
And find a poet who could create verse for each of my illustrations.
First choice was the inimitable Sir John Betjeman.
After much politicking by my publisher, Tom Maschler,
I finally met Sir John at his pretty house in Cloth Fair.
He delighted in the project, but at the majority
Of our meetings we drank port, discussed architecture and Highgate,
The Metropolitan Railway, and over a four-month period
Very little was achieved, so we amiably parted company.
Tom recommended William Plomer – who wrote twenty-eight
Marvellous, rollicking, rhythmic verses in just nine weeks.
The book, published in September 1973, became an enormous
Success, spawning record albums, dolls, toys, paint-boxes, trays,
Toby mousemugs, note-pads, greetings cards, a feature film,
Calendars, plays, animated cartoon films and posters,
Concerts with Deep Purple and Roxy Music at the Royal Albert Hall,
Strangely all owing their existence to a fish and chip wrapper!

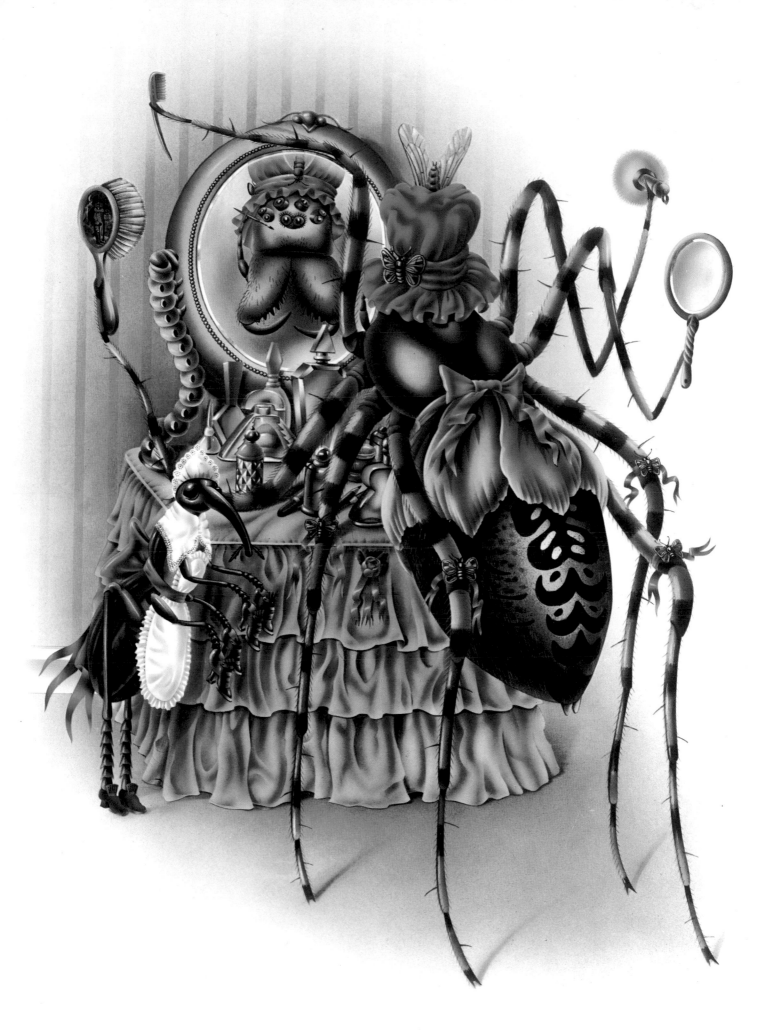

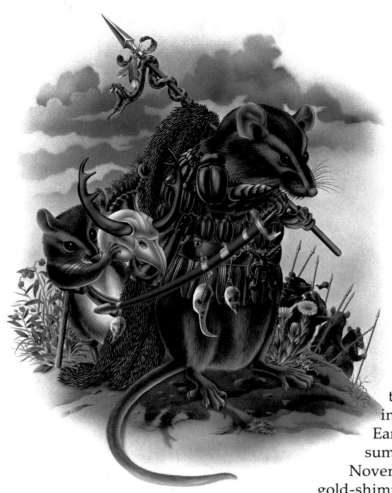

FROGS' BATTLE

'PANIC-STRICKEN at the news, the frogs
had fled back home to search out
forgotten weapons. Antique swords,
discovered rusting behind old pine
cupboards or supporting tomatoes
in the garden, were cleaned and
honed; bows were hastily strung;
branches cut from willows were
hurriedly stripped and flighted;
pitchforks, pikes, battered halberds,
cocking pistols, cutlasses, all and
anything that would slice, cut, prod,
or poke were pressed into service, until
the raggle-taggle army assembled
in the village square.
Earlier it had been a perfect, lazy
summer's day – the village of Swanton
Novers nestled in the folds of the silent,
gold-shimmered hills; a buzzard took his
pleasure swirling and poising idly in the golden light; trees, leaf laden, were full of
the chatter of newly fledged birds; bumble-bees fussed and droned around the
pink bells of the foxglove; clematis, ivy and dog-rose climbed in charming disarray;
and grasshoppers fiddled love songs to the silvery sun in fields heavy with cowslip,
primrose and cuckoo-pink.

Down at the Rose and Crown in the cool, shadowy bar, heavy with smells of
warm ale and baccy, the frogs had been taking their lunchtime leisure, with crusty,
black-beetle pies and frothy pints of bitter, amber, strong and cool, drawn up
slowly through the ancient concoctions of pipe from the dank, cold cellar below,
where bats were slow asleep parcelled in leathery wings, and the sightless worm
guzzled greedily through the beery mud beneath the ancient casks.'

I'd scribbled these lines in a jerky, almost indecipherable scrawl on a Water Rates
Demand, now rediscovered nested deep with broken cigarettes, cookie crumbs,
fluff and furry peppermints in the hip pocket of an old, blue serge suit.

Re-reading the incomplete fable in the guttering candle flicker of my studio late
one night, I tried to recall what had inspired this writing. What had panicked the
bucolic peace of the frogs of Swanton Novers to make them arm to the teeth with
ancient weapons and march off into the woods on some suicidal mission of war?

An Elegy on the Death and Burial of Cock Robin

Such a melancholic little tale, almost perfect in its construction, the first nursery rhyme I ever heard at infants' school, and one that continues to haunt me.

Who killed Cock Robin?
 I, said the Sparrow,
 With my bow and arrow,
I killed Cock Robin.

Who saw him die?
 I, said the Fly,
 With my little eye,
I saw him die.

Who caught his blood?
 I, said the Fish,
 With my little dish,
I caught his blood.

Who'll make his shroud?
 I, said the Beetle,
 With my thread and needle,
I'll make his shroud.

Who'll dig his grave?
 I, said the Owl,
 With my pick and shovel,
I'll dig his grave.

Who'll be the parson?
 I, said the Rook,
 With my little book,
I'll be the parson.

Who'll be the clerk?
 I, said the Lark,
 If it's not in the dark,
I'll be the clerk.

Who'll carry the link?
 I, said the Linnet,
 I'll fetch it in a minute,
I'll carry the link.

Who'll be chief mourner?
 I, said the Dove,
 I mourn for my love,
I'll be chief mourner.

Who'll carry the coffin?
 I, said the Kite,
 If it's not through the night,
I'll carry the coffin.

Who'll bear the pall?
 We, said the Wren,
 Both the cock and the hen,
We'll bear the pall.

Who'll sing a psalm?
 I, said the Thrush,
 As I sit on a bush,
I'll sing a psalm.

Who'll toll the bell?
 I, said the Bull,
 Because I can pull,
So, Cock Robin, farewell.

All the birds of the air
 Fell a-sighing and a-sobbing,
 When they heard the bell toll
For poor Cock Robin.

NOTICE
To all it concerns,
This notice apprises,
The Sparrow's for trial
At next bird assizes.

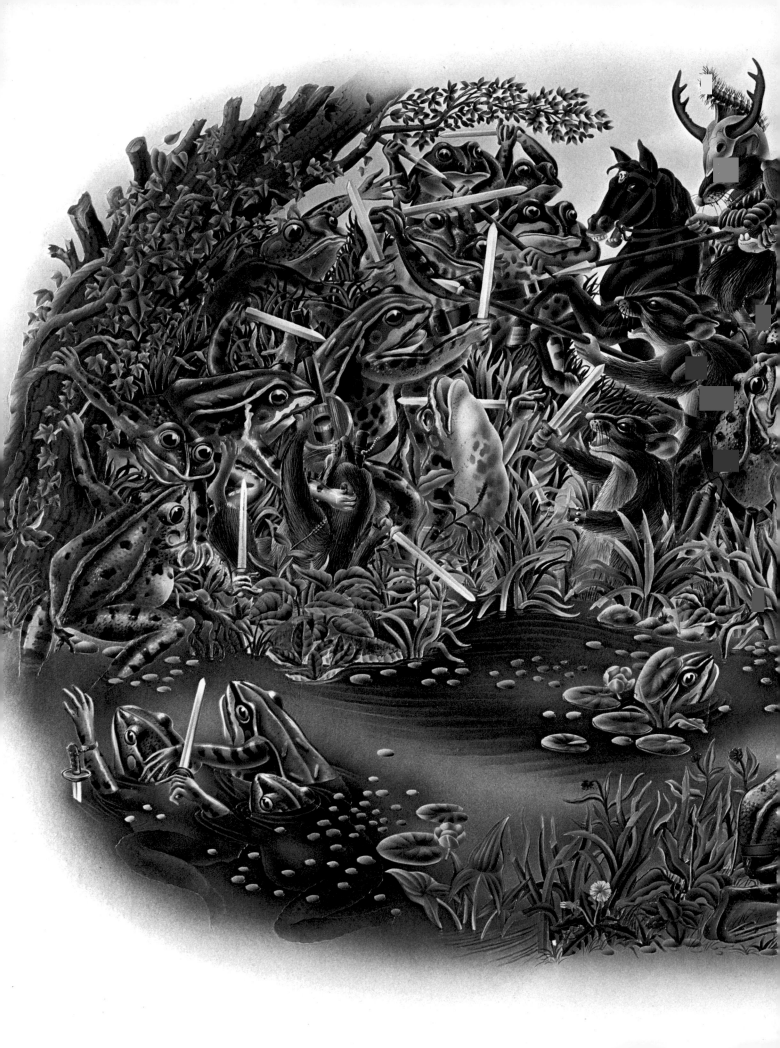

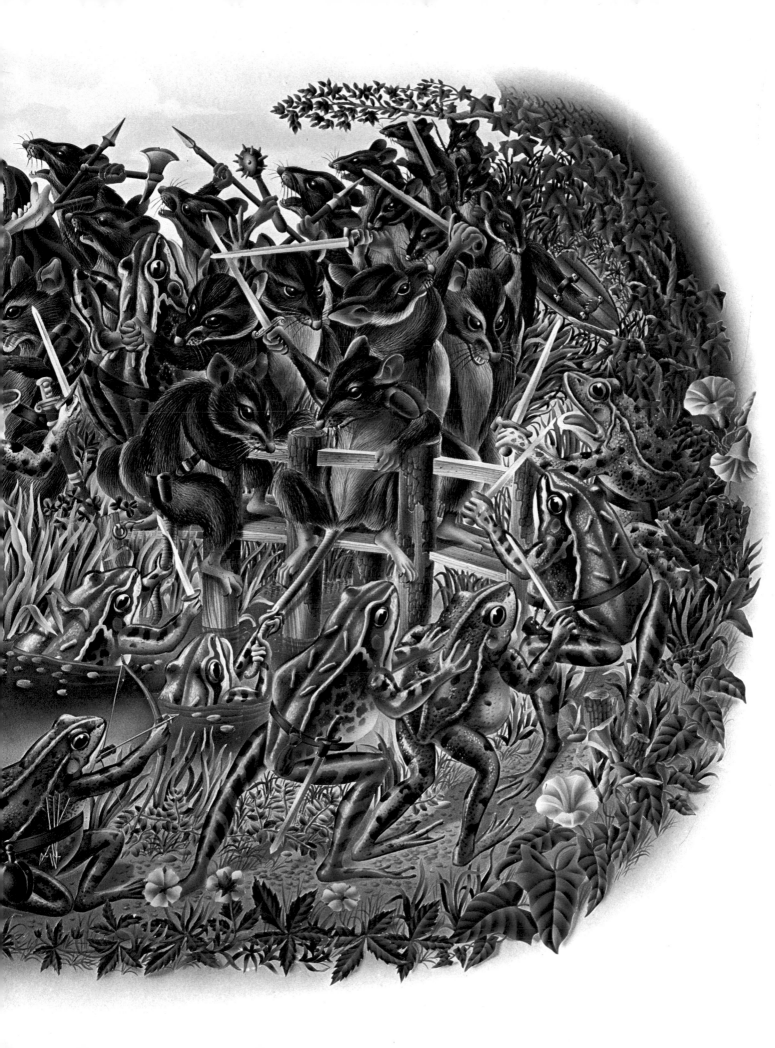

As I pondered, the shadows melted, the candlelight flared into bright sunshine which flickered in fits and starts on a dappled beech wood, heavy with bracken and the fragrant nosegay of rotting leaves and wild yews. Not too far away, mingled with the drone of flies and the whisper of leaves, I could hear the lilt of singing, croaky and rough,

Fish do swim	The long-eared Hare
And Birds they fly	Light feet for speed
Men do think	But the Frog
And reason why	He's the best of all
Horns on the Bull	Swims so deep
Hooves for the Steed	And leaps so tall.

Scuttling down a bank of fiery nettles, I came to a slow-moving stream choked with reeds and lilies, and there by a tiny log bridge the frogs, about twenty, were lined up in battle array, surveying anxiously the fields of corn beyond the far bank for signs of the expected enemy!

A Dragon, or a Giant perhaps? On the light summer breeze came the clank of armour, the squeak of leather, the frightening jangle of weapons, with the hiss and squeal of something awful through the shimmering heat. There on the ridge against the burning sun, I saw first one, then ten, then a hundred, big, black, evil, beady-eyed, yellow-fanged rats; horsemen and footmen in dense array, thicker than treacle, poured down towards the bridge, at their head a general on a great, brown horse, a rat of immense size, covered in dusty armour, hacked and dented from a thousand battles.

A great silence fell upon both armies as the shadow of Death, the Reaper, swept between their ranks, sending his minions of fear through the veins of rat and frog alike; then the rat hordes, amused no longer by the frogs' emboldened stance at the bridge, moved forward in a swathe of sharpened steel and fell upon the hapless batrachian army.

As I watched the frogs' gallant defiance from the safety of the wood, feeling a coward yet somehow unable to move forward to help, a blackness began to creep into all corners of the scene, the noises and stench grew fainter, the candle flickered and died, I was back in the silent darkness of my studio.

The following day I began working on the painting for the *Frogs' Battle*. I've never been back to Swanton Novers, or have any idea who won the Battle of the Little Bridge, but as it was my dream I've a good guess!

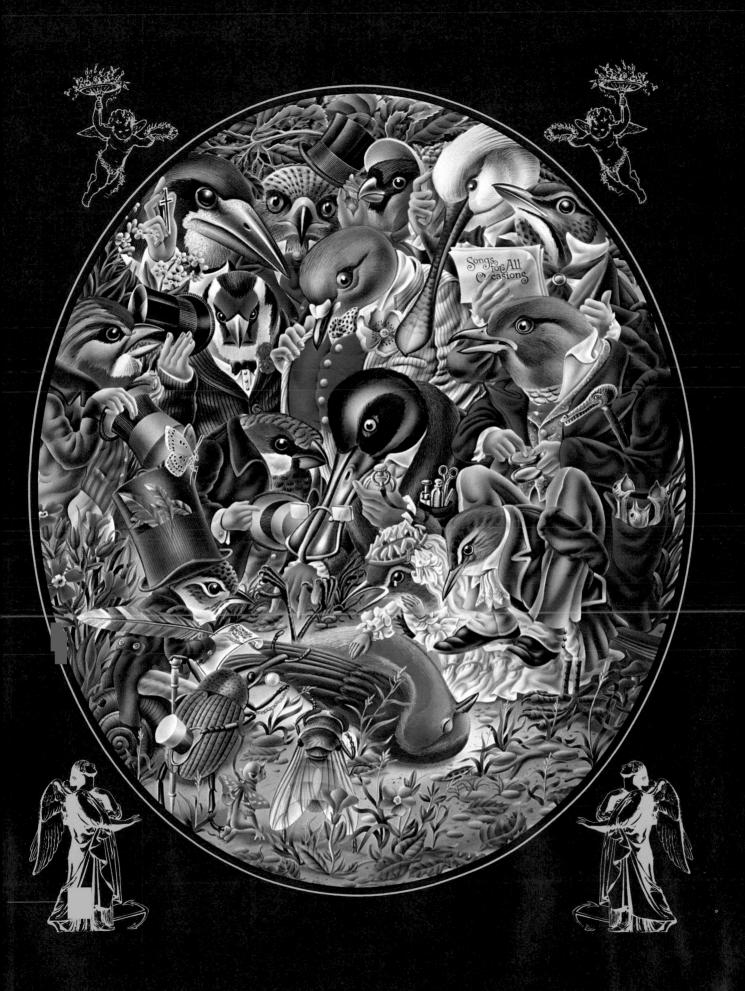

Tree Spirits

THESE TREE SPIRITS, Acorn, Conker, Blackberry, Thistle and Holly were inspired by a rather remarkable man. I'd been in the Ordance Arms at Stibbard in the County of Norfolk — alone — thinking about haemorrhoids and insomnia.

It was a blistering day, tar roads bubbled, old chewing gum fell from the undersides of tables like dead limpets, and the heat made the cornfields through the window dance and sway.

Then the bar door opened, a glare flared into the room like spacecraft from *Close Encounters*. Through the white light stepped a right character, a tall man, sixties, strong, bald with tattoos of naked ladies and butterflies dancing around his ears, one gold earring adorned with pheasant feathers, his suit a thousand skins, mole, rabbit, horse, Alsatian, sewn together higgledy-piddledy. The bald man sat next to me. He smelt of dead chickens, I knew the odour from East End slaughterhouses. We talked vacantly, my mouth moving, beer jumbling the words Gogol, Faulkner, Hemingway, silk panties, beans, punctured lungs. The wallpaper was hunting scenes, guys in red coats on stiff horses leaping all over people's property. I could hear the hunting horns. It was still over 90°. We traipsed together through dark fusty woods to his tiny hideaway home, a wooded shack, old, buckled, tarred black as death from top to bottom; great bubbled, bituminous rivulets cried down its cracked walls. Across the slatted roof in large whitewash letters facing the open sky was splashed 'Martians Welcome'.

Surely I was dreaming, I'd wake up soon on my old quilted bed back home, and eat cold plums from the freezer. But his house was full of hot smells of stale feet, rotting something-or-others and festering crockery. On one wall a pentangle, chalked white, jiggered and wheeled. He produced from nowhere a vast, ornate bubble pipe. We began sucking down draughts of dry, deadly smoke, giggling. My brain folded, colours kaleidoscoped, I was upside-down, pouring tea for the Mad Hatter.

Later, after dusk, I rolled through the darkening wood towards home. There was a strange magic everywhere, leaves glowed bright orange, the sky was mauve as a coronation cloak, all around Faery Folk abounded, fays, sylphs, elves, all cavorting, dancing, as the sickled moon sliced up the sky, to strange, ethereal music, scraped on weird instruments by Tree Spirits. If I'd been Beethoven I'd have rushed to compose their music into a *Sylvan Symphony* it was so beautiful, but all I was good for was this picture!

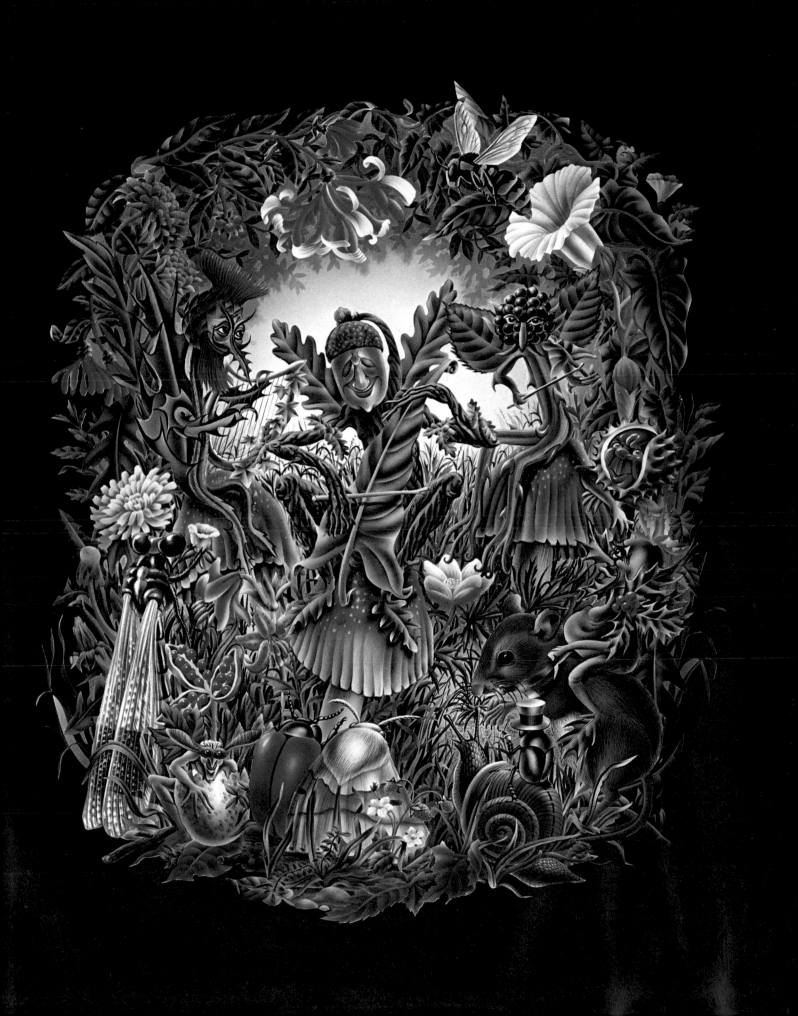

Aiken Drum

F ALL fairy-tale fruit and nutters
Aiken Drum takes the biscuit,
Cutting a bizarre, racy and somewhat malodorous
Nursery rhyme figure with his sartorial, roast-beef suit,
Cream-cheese hat and haggis bags!
I've often wondered if in his corned-beef cottage
With its gravy pond and sausage trees
He didn't have double-breasted, pin-stripe pastrami pyjamas,
Hickory Ham overcoats and single-breasted Spam sports suits?

The Surprising History of Aiken Drum

There was a man lived in the moon, lived in the moon,
There was a man lived in the moon,
And his name was Aiken Drum,
And he played upon a ladle, a ladle, a ladle,
And he played upon a ladle,
And his name was Aiken Drum.

And his hat was made of good cream cheese, good cream cheese,
And his hat was made of good cream cheese,
And his name was Aiken Drum.

And his coat was made of good roast beef, good roast beef,
And his coat was made of good roast beef,
And his name was Aiken Drum.

And his buttons were made of penny loaves, penny loaves,
And his buttons were made of penny loaves,
And his name was Aiken Drum.

His waistcoat was made of crust of pies, crust of pies,
His waistcoat was made of crust of pies,
And his name was Aiken Drum.

His breeches were made of haggis bags, haggis bags,
His breeches were made of haggis bags,
And his name was Aiken Drum.

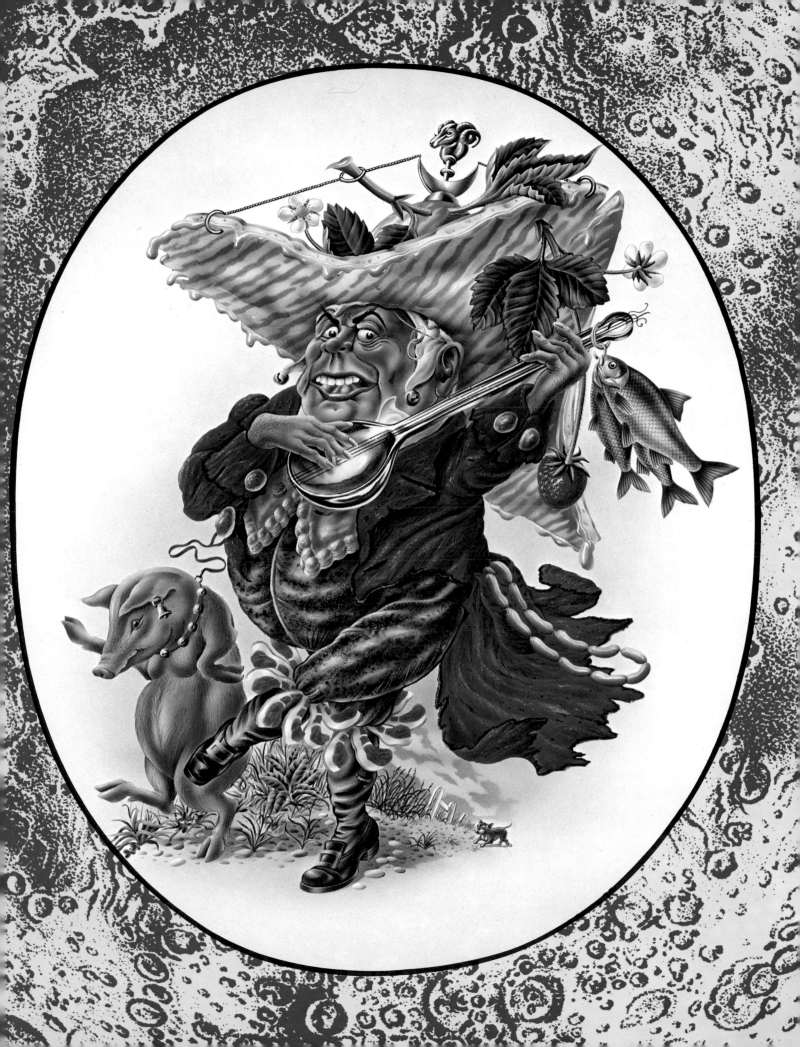

PANDEMONIUM

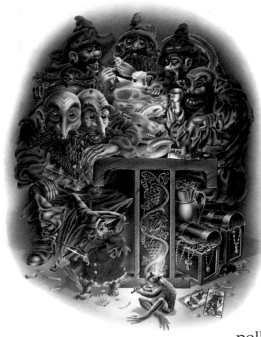

TWENTY-SEVEN years ago, at Albert Road Junior School, in my short grey-flannel trouser days, with silver snake-buckle belt and sticky pockets stuffed with headless lead soldiers, 'dripping doorsteps' and rock-hard conkers, Basil Baines was my Class One teacher.

A grey cobwebbed Victorian museum-piece, his 'fifty shilling' suit liberally pollened white with sixty years of blackboard chalk dust, he enjoyed using alliteratives to teach, joke, cajole and admonish us scruffy, runny-nosed kids with cap-sized heads. When chastising a child, he moved, a scuttling crocodile, all teeth, down classroom aisles, curdling ink, draining blood from scabby kneecaps until he was eyeball to terrified eyeball, inches from his hapless victim, leering. Somewhere, deep down in his worn tubes, an asthmatic rattle chuckled evilly. When he finally spoke, nicotined spittle sprayed, baptising the woebegone sacrifice. Then came the halitosed breath: pilchards, whale meat, the stench of tramps' feet and rotting colon rushed out, escaping like New York sewer steam, stinging nostrils and smarting eyes. Next the vituperation! 'Aldridge arise, arch enemy of academic adroitness, agoraphobic agnostic, aggravating aestivate . . .' He became better humoured as the aimless verbiage rambled on. If he went past ten words he usually forgot why he had ever started, and a ghost of pleasure would flicker, haunting his pale-blue, vacant eyes. But God forbid that he stutter, fumble to a halt after only five or six, this meant a severe slap on the side of the head from his hard bony hand, leaving a huge, swollen, bright red ear that throbbed and glowed for days and made sleep difficult.

Recalling Basil Baines had given me an idea to produce a book of alliterations, called *Pandemonium*, an *ABC of Fascinating Flights of Faery Fantasy*. I illustrated T for Trolls, then wrote, 'Tall, tale-telling, tavern trolls, tucking into tenderloin, tetchily toasting to tarot, torture and taciturn toads.' Drew up D, penned, 'A dozen, dallying dwarves disturbed a dozing dragon, despaired as dangerous demons, devils drubbed . . .' Slowly the book disintegrated, twenty-four more letters to worry about. No there must be other ways to make some easy money. Deep-sea diving, gold prospecting, kamikaze pilot . . .

T is for Trolls and Treasure, 1974
D is for Devils, Demons and Dragons, 1974

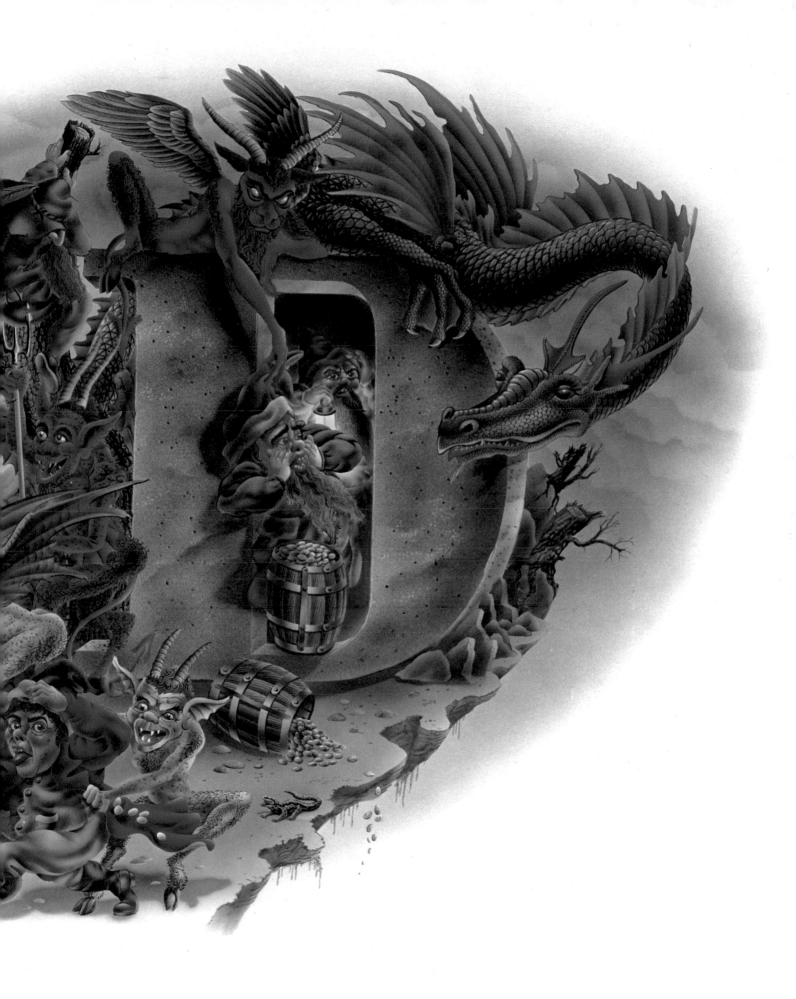

The Redcap

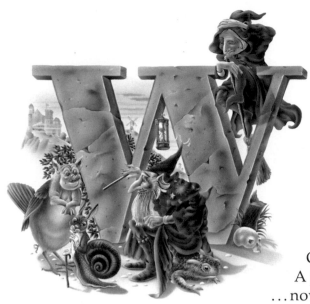

HEN I STARTED *Pandemonium*, a book
On the Secret Commonwealth of Elves,
Faeries and Goblins, I put the word
Around museum madmen, road-sweepers,
Grave-diggers, the Womens' Institute,
Scuba divers and know-alls, 'If you meet
Anyone who's seen real faery folk
Or has a story to tell, put them in touch.'
I got some funny looks. At six o'clock
One morning the telephone jangled.
A joker says he's a Redcap... can we meet
... now... there's a car waiting... outside.
Maybe he's a madman, murderer, matador, Sweeney Todd or Christ,
Driving a hearse like Nosferatu, but there's only a battered
Old radio taxi. I watched London's working-class windows light up.
Deep in suburbia we stopped by a tatty bungalow, cement gnomes
Hid in a jungle of dandelions, two fresh pints of milk
Waited on the front step. What the hell? I was scared,
It's not every day you meet a blood-drinking goblin.
I knocked, 'Just push it open', squeaked a bone-dry voice.
Dark brown splashes stained the wallpaper and carpet.
A radio played, 'You're a Pink Toothbrush', among the fires
And the smell of cats — I bet he eats them — the Redcap stood
In a hutch-sized bed-sit, his fat white paunch sagging out of dirty
Striped pyjamas, a Mickey Mouse clock semaphoring life away.
'I've only a few minutes, thanks for coming, have to be
At the office by 9 a.m., I look after the lavatories.'
His thick and oily cough was clogged with tar. 'About your book,
Redcaps are not all bad — sure my ancestors were cannibals,
Drank blood, pillaged, plundered, murdered, raped and tortured,
But that was a long, long time ago. Please, we're normal,
Hard-working little folk, not Nazi stormtroopers quaffing blood.
The idea of steak tartare revolts me, I wouldn't hurt a fly.
People should forgive and forget, my loves are ice-cream,
Geraniums, Mabel Lucy Atwell books...' 'And the liced eyes
Of dead birds!' I mocked. White with shock, he scurried
To another room. I heard splashing, retching, a tap run.
Reputations can be hard to change,
I drew the Redcap as tradition made him.

W is for Wands, Witches and Wizards, 1974
R is for Redcap, 1974

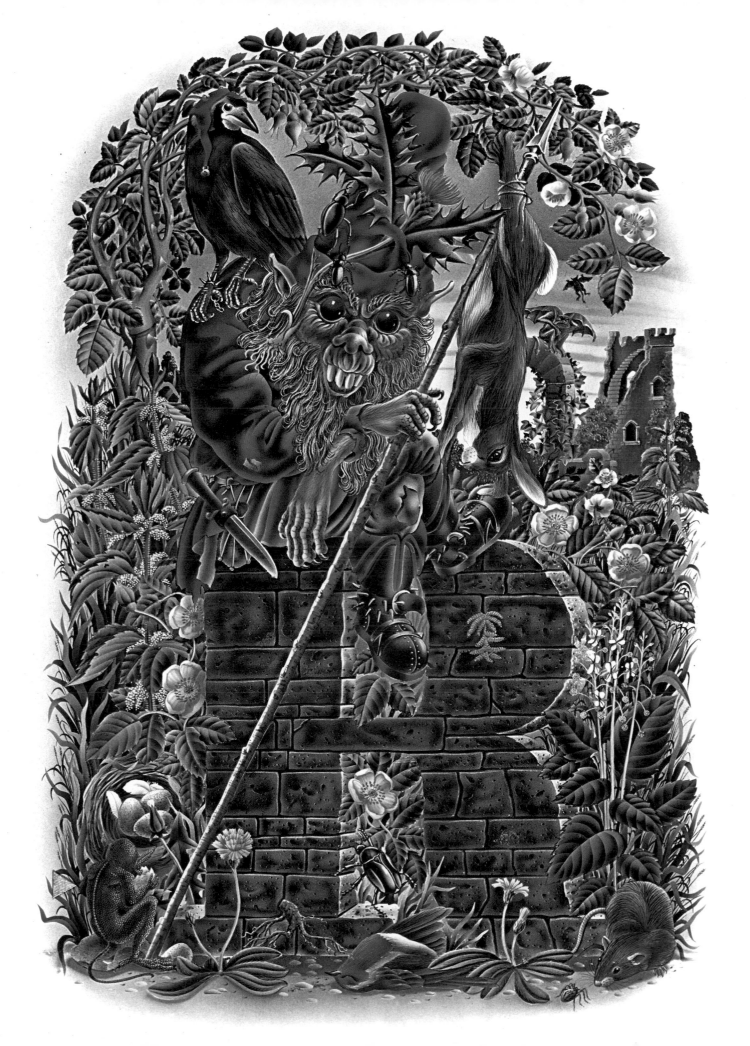

Grandfather Mitron

City night was lurking
Behind the venetian blinds,
Its opalescent fog infested with sharks,
Rubber-lipped muggers, rapists,
Lizard-skinned junkies, gutter drunks,
Murderers stepping quietly over their dead.
A recluse, safe in my studio,
Where candlelight pulsed and blinked,
I read *Grandfather Mitron*,
A manuscript by Richard Adams.
My next book to illustrate? Maybe!
It was dark fantasy,
A mythic empire like Tiahuanco,
Enigmatic and enshrouded in religious mystery,
Hidden by time. Its violent splendours,
Melancholy flesh and moon-dim dungeons,
Were a chance to exorcise
Long nurtured graphic harpies,
To show off Quattrocento techniques.
While herbal shamans danced
To Britten's *War Requiem*,
Visions seeped like opium
Through my mind and fingerbones,

Right: *The Priest Discovers Poisoned Sweets, 1975*

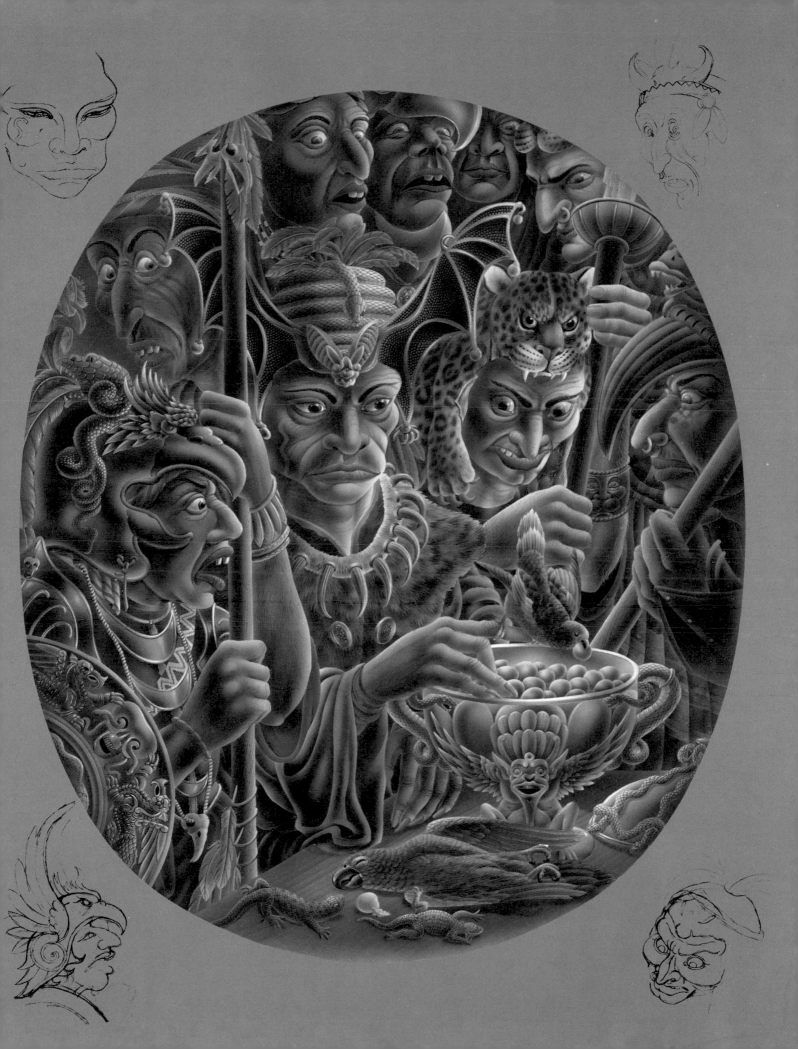

Images of improbable, midnight landscapes
Bristling with gaunt trees, coppices,
Thickets, all skeletal and full of birds
With rats' heads, cockatrice tails,
Chimaeras, ghouls, phantoms, dead shapes
Stealing past, deep in oozy blackness
Silhouetted against the feverish,
Waning moon. I dreamed of palaces
With basalt columns, gates of silver filigree,
Ivory seats, tapestries worked with pearls,
Black opals into birds' breasts,
And creeping things. Warlords,
Moving like automata, clad in black armour,
Blood-flecked, shining dark as ravens' wings,
Holding silver-gilt spears dinted by war
And shields wondrously enwrought with salamanders,
Their scales of amethyst and yellow zircon,
Their glowing eyes sapphire by moonlight.
The ghosts of Bosch, Brueghel, Grandville,
Ensor, Redon, sorcerers of the phantastik,
Weaved among my dream, laughing at my visual
Precocity. Each conjured forth bizarre nightmares
For my approval. Gleefully, they revelled
In their unearthly powers.
 Then I awoke
And found the goldfish dead – floating flat, stiff.
Beneath a laughing, bone-yellow moon,
I tried to bury it in the frost-hard earth of the garden.
Finally I flushed it down the crapper
Along with the visions of Grandfather Mitron –
Why work for 5 per cent?
I was tired of climbing broken ladders!

The Princess, 1975

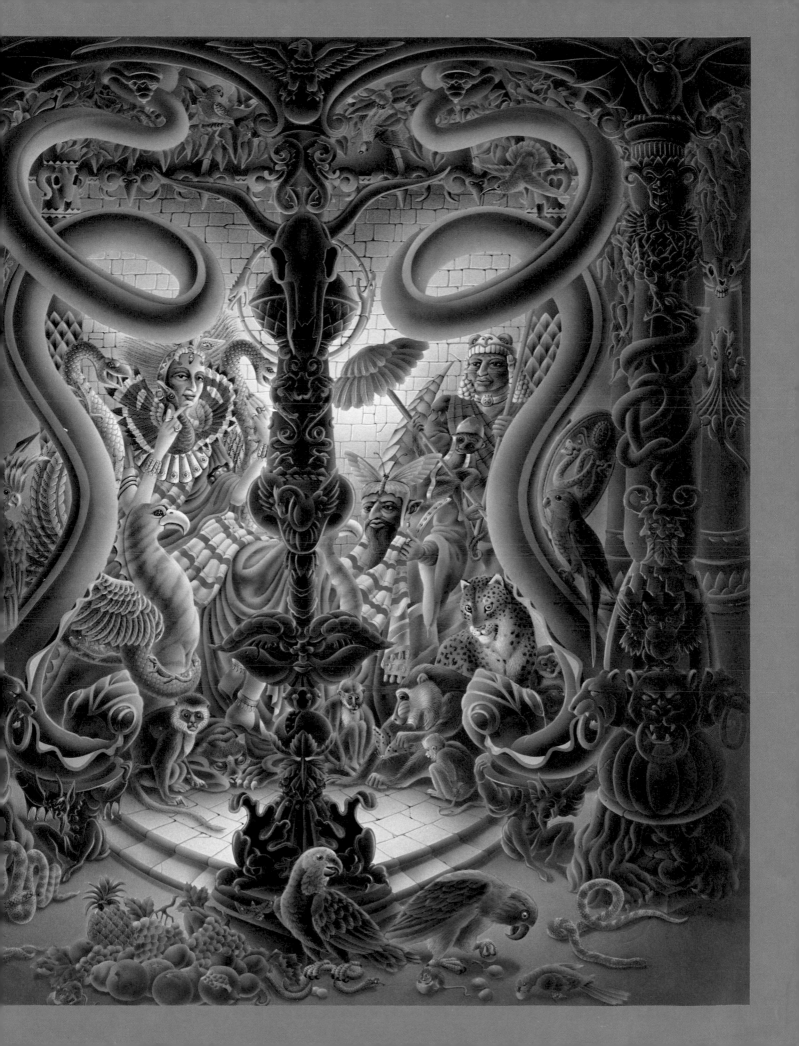

The SHIP'S CAT

During the summer of 1975,
Valerie Kettley at Cape
Handed me a typed poem.
Could I guess the author?
I read through twenty-four rollicking, swashbuckling verses
And tentatively guessed John Masefield.
Wrong – it was Richard Adams,
Author of *Watership Down*,
The book everyone was rabbiting about.
Would I like to illustrate the poem? Yes!
Months later, after all the wheels had been oiled,
Publishers, agents, percentages, etc.,
I met Richard at his charming house in Canonbury
(Before he became a tax exile).
His wife cooked sausages and mash,
While we talked about
Tom de Chat, hero of *The Ship's Cat*,
English porcelain, real ale revival,
The decline of book illustrations,
Secrets of the Civil Service,
The magical and mythical
Undercurrents of Pink Floyd music,
And surrealism in the work of Lewis Carroll.
Research for the book took three months –
Costuming, ships' rigging, ratlines,
Feline physiognomy, sheets, clews,
Halyards, lanyards, Elizabethan armour,
Guns, swords, every detail
Right down to with which hand
Queen Elizabeth would hold the sword
To dub Tom de Chat a knight.
Trips to the Maritime Museum
At Greenwich, searching
Through dusty scrolls
For shipwrights' plans
To English galleons.
Everything had to be right
For Tom de Chat.

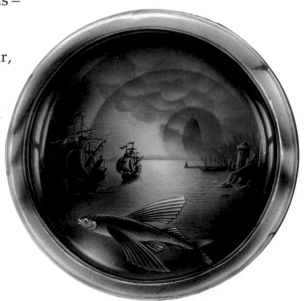

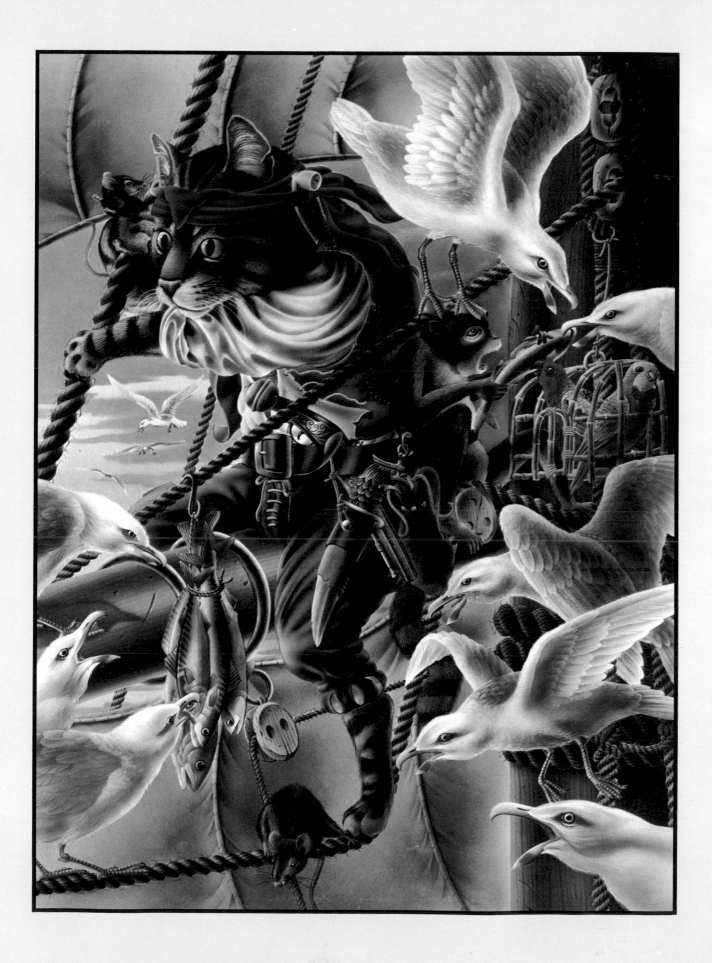

Beverly Hills.
I'm staring at the blue lake of the swimming pool.
Red, pink, fuchsias scramble up along a glaring white wall,
The air is loud with TV cackle, canned humour, dollar dreams.
The bellboy midget keeps winking at me.
Room service screws up, brings me two double
Tequila Sunrises on someone else's room number.
On my left arm, a girl all bum and boobs insists
She knows me, on my right Ursula Andress!
Drinking orange juice waiting for a break in my tan.
Warren, Jack and Steve watch enviously.
The sun's microwaving the city.
Here at the Beverly Wilshire it's all Waldorf salad
Long drinks, and short bikinis.
Hell, how can I be expected to think about
The Ship's Cat here – galleons, halberds, Drake?
The tannoy blares.
'Mr Aldridge wanted on the telephone' –
I move through the basking lounge lizards
To the courtesy phone, pick it up.
'Hello. Mr Aldridge, Tom de Chat here, I'm down in the lobby!'
Oh well, back to work!

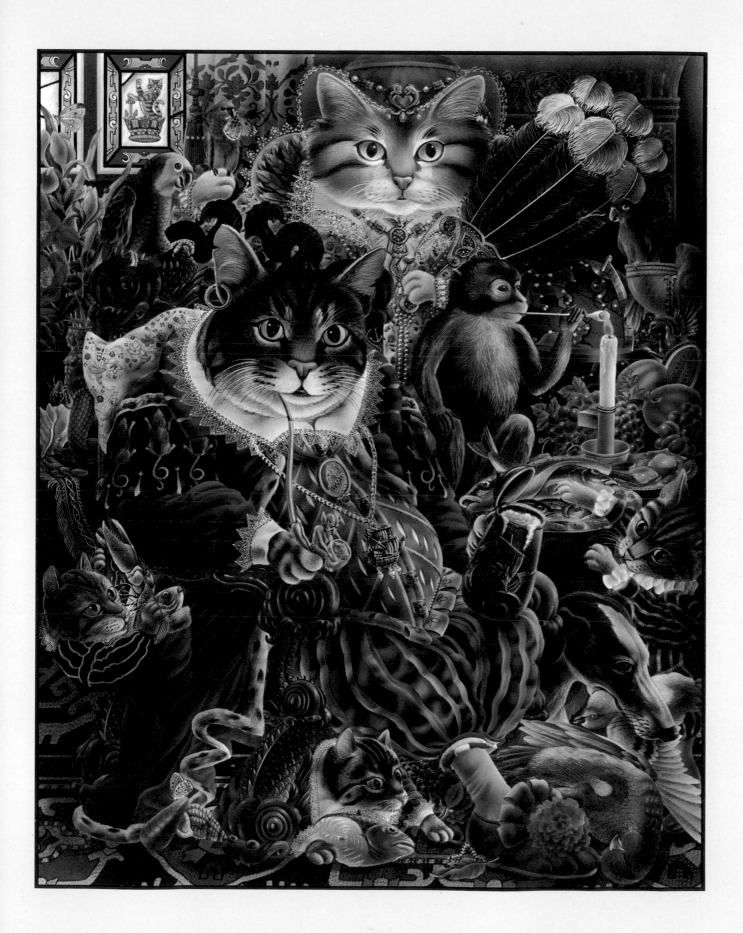

THE ALBUM COVER

The days of on-and-off electricity. Someone was striking over the usual when I got a call from Dick James – remember Dick? He sold the Beatles' Northern Songs to Lew Grade and made millions, so the papers said. Would you believe that at the very same time he had a tea-boy named Reg Dwight working in his studio, and this 'char wallah' blossomed into Elton John? Naturally, everyone resented Dick for making it twice.

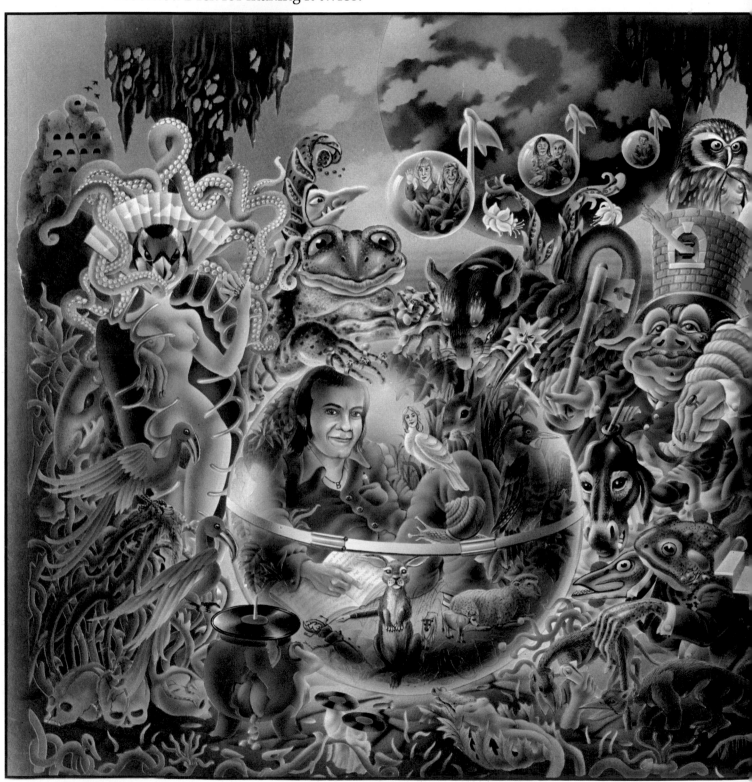

So Dick asked me to come down to London to meet Bernie Taupin at the Sportsman Club, wearing a tie! They told me Bernie and Elton had a new album: 'Captain Fantastic and the Brown Dirt Cowboy'. Would I do the cover? Certainly!

Back in Norfolk, I commenced drawing musical nightmares and then broke my thumb playing football. Hence the album's strange dedication, 'For Alan Aldridge, his imagination and thumb'. Captain Fantastic went to number one on its first day of release in the U.S. That's unique.

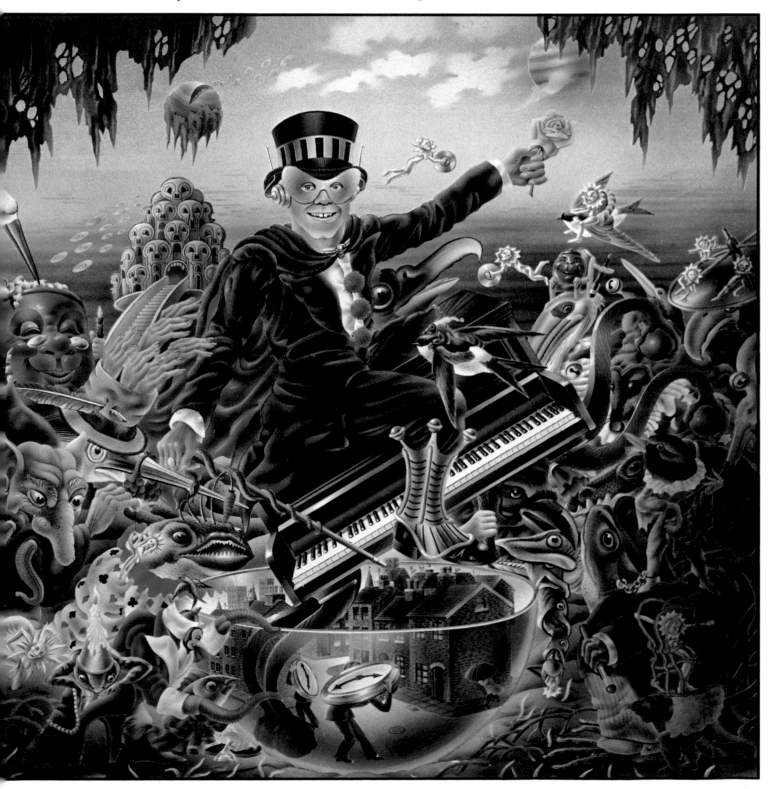

THE EPIC EXPLOITS OF
CAPTAIN FANTASTIC
IN VOYAGE TO POPTROPOLIS

The idea to create an animated feature film came while I was preparing the album cover. I talked to John Reid, Elton's manager, at Morton's in Berkeley Square, and conveyed my vague ideas for a cartoon hero, a new Mickey Mouse. He saw the potential immediately.

Next, in Amsterdam, I discussed the Captain's development with Elton. Somewhere over the North Sea I lost my voice, so the movie was discussed in sign language, and given the thumbs up. Universal Films sent Bernie and me to Barbados to write the script — it's a hard life!

Sadly, since 1977, the film has been on and off with the regularity of a pinball light from the Captain Flipper Machine, which was designed to be a movie tie-in, using my characters Champagne Charlie, Fastbuck, The Captain, Bitterfingers, etcetera... As a commission, it was bliss. We winged into Chicago, limoed to fancy, four-star accommodation, had plenty of mescal (with real worms) while yarning with old-time, pinball artist, Norwegian Daves, and watching his exquisite penwork as he inked in yet another 42B cup. There'd be as much pinball as we could play – silver balls, clanging bells, flashing lights, digital buzzers, kaleidoscoped, rioted and flared like a crazy LSD trip. Later, dazed, I'd head out into the windy night of big cars and sullen neon, beaten but happy.

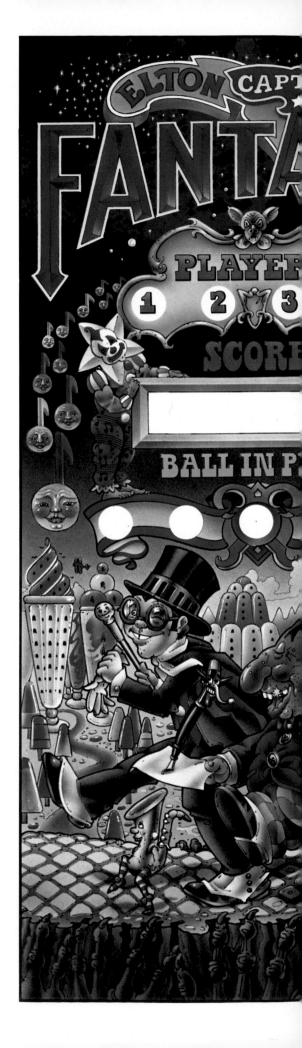

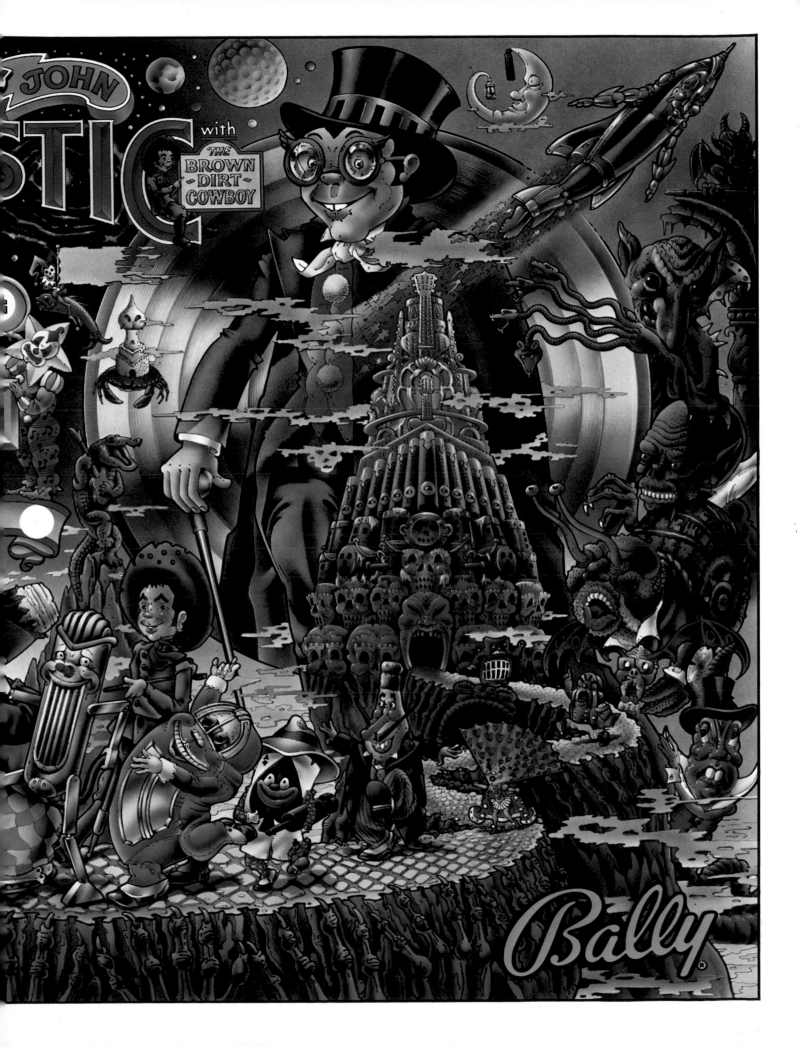

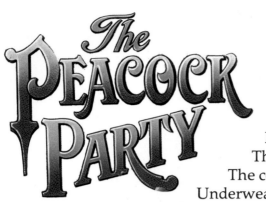

The Peacock Party

I'd just arrived back from Los Angeles
Still rattling with undissolved vitamin pills.
Called by my local, the Southampton Arms.
Always good to wet the whistle with a good
Noggin of English ale as quickly as one can –
This November night I was mummified against
The cold – overcoat, three-piece suit, thermo-electric
Underwear, tartan lumberjack shirt, (always difficult to wear
After the *Monty Python* song 'He's a Lumberjack, but he's O.K.!')
Anyway, here am I, sitting in the very seat where Voltaire wrote
His *Philosophy of Platonic Ideas*, worrying about my mingy bank manager,
Overdraft, divorce, tax, V.A.T.,
And whether I'd get mugged on the way home. An Irish navvy,
Huge, bare-chested with enormous, tarred knee-pads to his trousers,
Passed on his way to the Gents muttering 'Surely the vestments
Of the Catholic Priesthood are symbolic of the Sun and Cabalistic
Division of the Universe!'
 I needed to think about poets
For *The Peacock Party*. After eight, long, dreary months,
A million feathers, four miles of beak, and ten tons of talons,
Twelve plates of eagles, ostrich, tailor birds, parrots, owls,
Nightingales, etc., were complete. I'd ask Shakespeare
But he's on night shifts all this week at the glue factory,
Anyway there's a rumour about here that some geezer
Called Francis Bacon wrote all of his stuff, don't ask me why!
So who? I could buy Lord Byron a pint of mild and bitter
And see if he would fit me in between his noble work
For Health and Efficiency.
 Then there appeared vaguely,
Through the cancerous wreaths of grey smoke,
A figure moving slowly towards me,
Shadowy like a still from Carol Reed's *Third Man*.

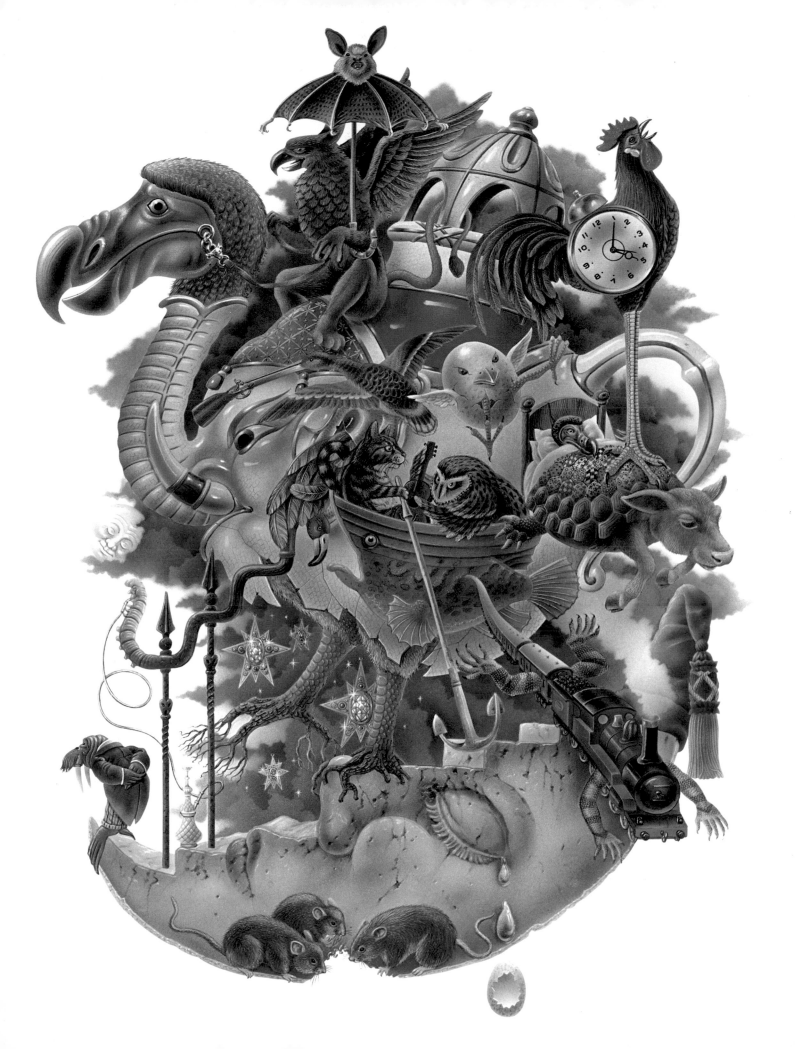

A gentleman materialized, a moustachioed
Harry Lime, camel-hair coat, silk scarf,
Handsome, mid-sixties with a Heidelberg scar
Sliced down one cheek.
He bowed and made an introduction.
'George E. Ryder of Seraglio Highgate,
Poet dear Boy!'
He flopped into the seat next to me
Without more ado or invitation recited –

 Eagle, eagle flying high, fixed between the earth
 And sky
 Ever searching with your evil eye, for a victim
 Yet to die
 Saw you from the heavens' sweep, upon my flock
 Of resting sheep, and rend one with your fearsome beak
 Take it to your mountain keep.
 As I saw then I did vow that I would seek you out
 Somehow,
 And when I found your satanic bed,
 I have sworn by Heaven to strike you dead.

And so on through five more verses
In a deep, rich, sherry-oiled voice.
When he finished he gave a nudge and a wink
'Now one for the ladies, they love it!'
He glided into the silky rhythms of 'The Swan'.
What a lad – what coincidence.
Asked him if he wasn't Tennyson in disguise
Trying to get some freelance, he assured me
He wasn't – George was sixty-eight, and
Never been published – I believe in fate,
Peacock Party would be his first book!

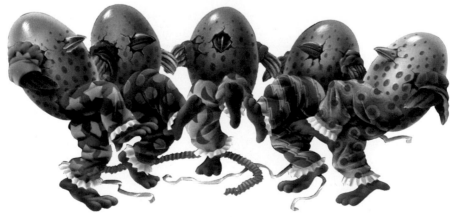

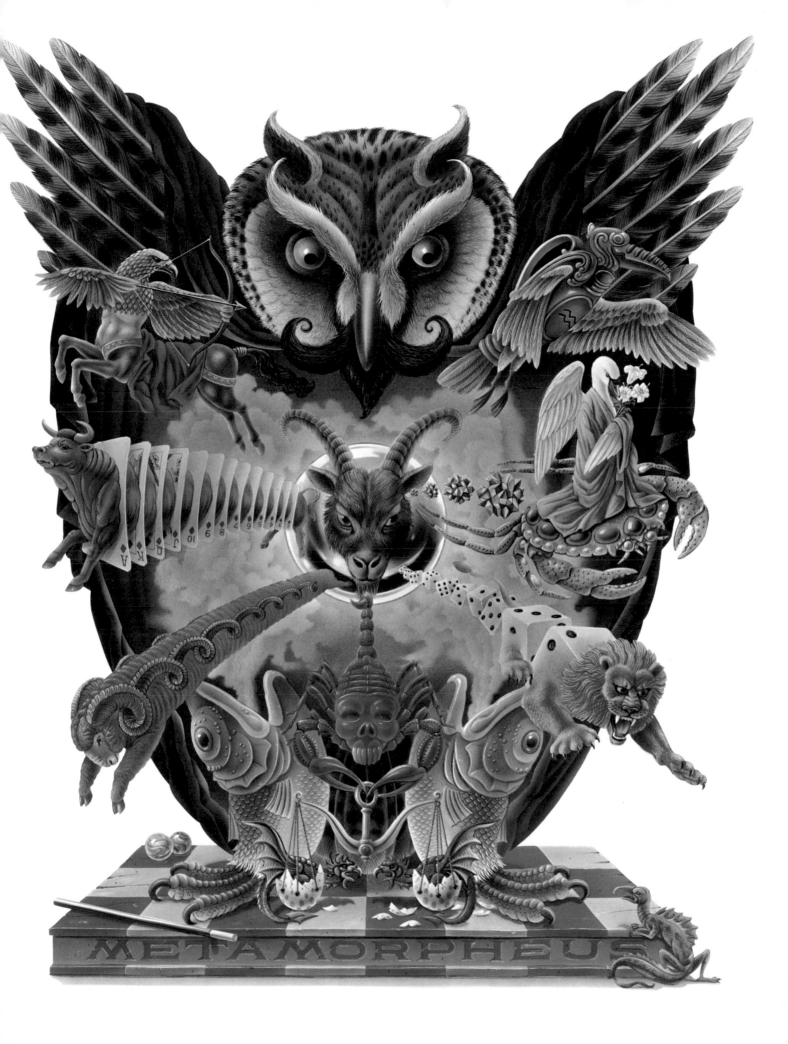

METAMORPHEUS

The LION'S CAVALCADE

Late night in Manhattan.
I caught a No. 7 bus
At 52nd on 5th Avenue
Going down to 8th Street,
Tumbled my 30 cents into the coin box
And moved into a dark, steamy,
Raucous jungle, alive with
Jibbering screams, phantasmic shadows.
Fetid the air, the foulest I've ever breathed, it stank
Of rotting feet, decaying carcasses, rancid hamburgers,
Urine, and stale pasteurized milk.
The ceiling of the bus glistened, suppurating huge
Stalactites of oily pus − I retched. Two furry things
Moved around my feet, licking.
As the bus lurched and bumped
Down the concrete canyons of New York city,
Bright flashes of hellish light from passing roadworks
Illuminated my nearest companion, a pig
With pink, sweaty skin, tiny slit eyes that danced.
Blood red, small upturned nose with gaping nostrils.
His ballooning cheeks revolved, chewing
Endlessly − the mouth, widest I'd ever seen,
Swooped from ear to ear when it opened.
His hand darted up, ramming some brown, smelly
Substance deep down into his cavernous throat.
'Strong meat', he muttered to no one in particular,
And where is sweet Puck? − he closed his mouth and
Recommenced chewing without need of an answer.
A woman, no actually it's an old leathery lizard
Shedding skin, dressed in a feather bonnet, floral coat

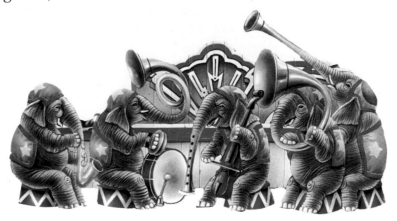

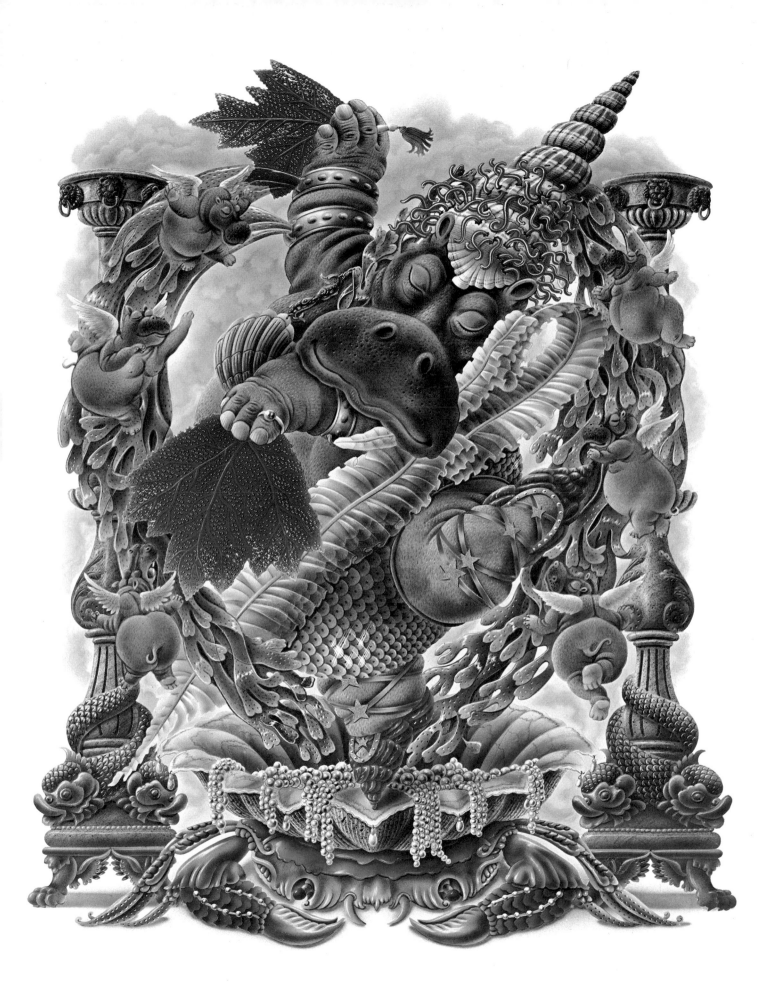

And wellington boots, leaned forward, licked up
The spittle, gravy and morsels of meat
That dribbled out of the pig's mouth
And down his innumerable flabby chins.
I moved, less by volition, more by the press
Of bulky passengers, towards the rear of the bus.
Glimpsed strange, mangy rodents, snakes, wingless hawks
Seated, hunched in overcoats, scarves and working overalls.
Rustling, sighs, coughing – such coughing.
One old rat hacked, his oily lungs hanging from
His mouth, inflated like grey Mae Wests.
Again in the dancing half-light, an alligator,
Grinning, chews on a dismembered human leg
Replete with white sock and blue suede shoe.
Suddenly my own left leg went totally numb.
I thought of the alligator, then out of the steamy gloom
Meandered up from my trousers a python
Of immense girth, in bowler hat, bow tie and Oxford collar,
Entwining itself around my waist and arms.
Its frantic tongue flickered near my face
Coated in the fur of many dead animals.
'What hope is there in this ordered madness?
Salvation lies in the wilderness of the mind!'
It hissed – such was its grip I was unable to speak.
It muttered something about rescued relationships
Then slithered like some surreal water-pipe
Plagued with green and yellow moss
Over my shoulder and was gone.
Something screamed, 'We are all protons!'
All around in the sweaty gloom black shapes
Bobbed and jostled, mouths broke through the scum
Moaning and jibbering – skeletons of once-furry animals
Littered the surface of the lurid sea.
A coffin glided on through the nightmare
Towards the front of the bus.
'8th Street', yelled the driver – I stepped out
Into the melancholy Manhattan night
To a more dangerous human jungle.
The journey, its creatures, would be the inspiration
For the *Lion's Cavalcade*.
Is the book really anthropomorphic?

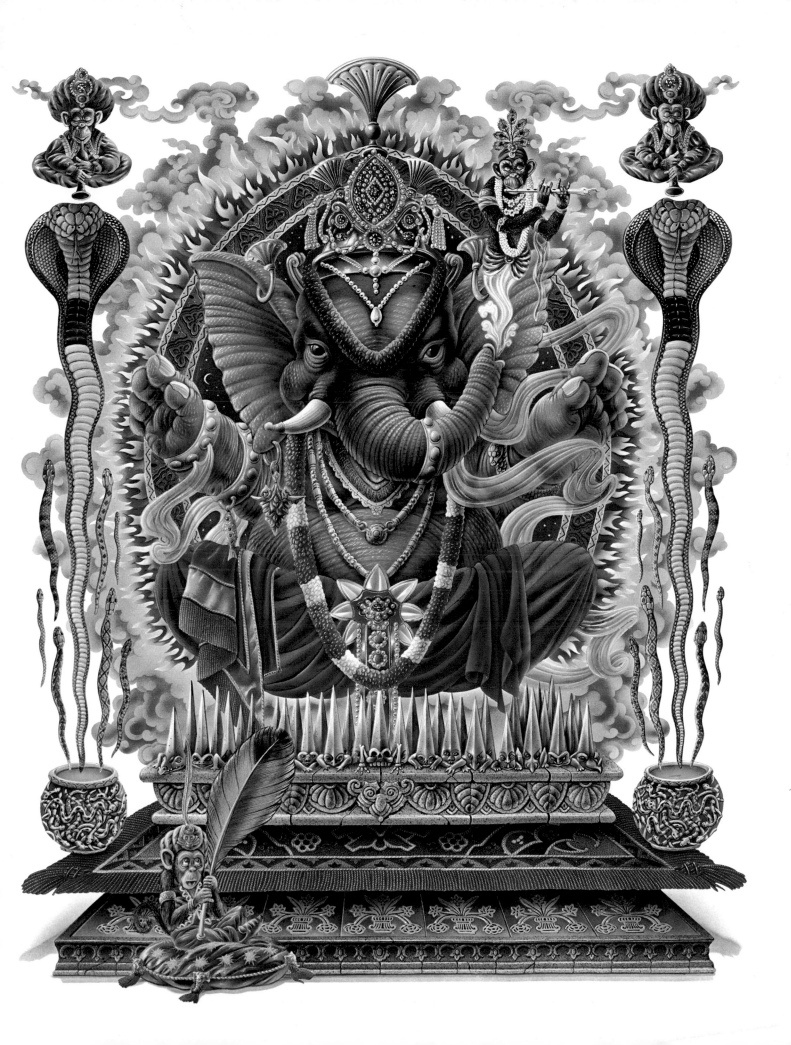

Finally one thing bothers me about this 'Art' game. You see, I know
I'm a self-balancing, 28-jointed biped, made up of some kind of elemental
'bouillabaisse'; carbon, hydrogen, oxygen, nitrogen, magnesium, calcium,
sodium, sulphur, phosphorus, iron, chlorine, fluorine and iodine, all stirred
and poured into a seamless two-layered, dermal and epidermal skin-bag with
sebaceous glands rendering it waterproof, yet covered with a pneumatic air-
conditioning system, allowing steaming sweat, waste salts to be expended out
of the body through a billion subterranean coiled tubes.

This vast, electro-chemical reduction plant is shaped by 206 bones, giving
the whole a rigid framework; these with their 28 major joints help in
locomotion and give protection to vital organs. Great lumps of blubbery offal,
reduction plants, energy-storage tanks, pneumatic pumps doing weird and
wonderful miracles with hamburgers, kippers, tuna melts, chicken tandoori,
alchemically changing from junk food to physical power! The soggy liver
creating green bile, and a digestive fluid converting sugar to glycogen, the gall
bladder, pancreas and stomach – food reservoir of the alimentary canal,
collapsible sac-like organ usually found hanging in vast tyres over people's
trouser belts, bloated, distended from a lifetime of processed food and gassy
ale. The omentum – vain supporter of the belly. There are kidneys – if they go
wrong you can spend the rest of your life in the men's room. The heart,
pneumatic pump – which despite booze, cocaine, amyl nitrate, cigarette
smoke, acid, aspirin, sex, stress, strain, you hope, despite every abuse, will
keep banging away without service for some 70 years or more.

Colon, bladder, all sorts of tubular members and passages are stuffed down
your legs and into your arms, hydraulic systems, there are 62,000 miles of fine
tubular capillaries, endless veins, blood conveyor belts, transporting 6 litres
per person! Blood, with its plasma, 80 per cent water and fibrinogen, red
corpuscles – 5,000,000 in a cu.mm, curiously 10 per cent more in men than in
women; white corpuscles – centurions of endless red rubber tunnels,
attacking and devouring bacteria. There are spongy, ductless glands, squashy
pineal, flabby thyroids, adrenals, pappy pancreas and sloppy spleen all
bubbling, hissing like demented chemical retorts. You've got a vast telephonic
network; the cerebro-spinal nerves – 12 cranial and 31 pairs in the spinal
cord – sending out messages, orders to muscles, fibre-like tissues
constituting 45 per cent bodyweight that are attached by grisly cartilage to
jointed bones – go to the bank, lift left arm, nod head – if they achieved as
many crossed lines as the G.P.O. we'd be running in circles for ever. Flaccid
lungs hang like dead bloaters behind the rib cage inhaling fresh-air fumes and
cigarette smoke, then exhaling used car fumes and cigarette smoke, slowly
turning deathly grey.

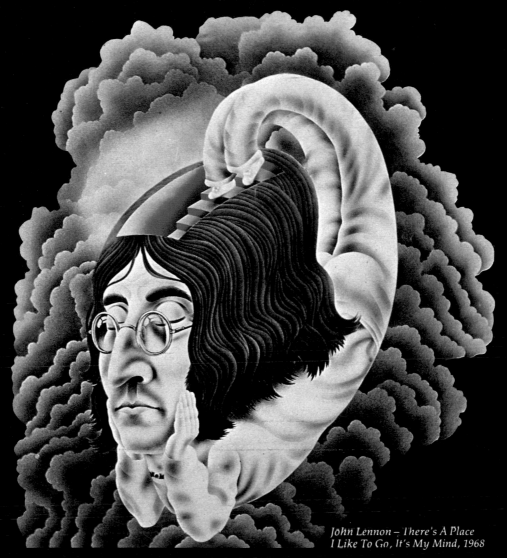

John Lennon – There's A Place
I Like To Go, It's My Mind, 1968

Atop the torso, a turret, the skull formed by 22 jigsawed bones, inside, a few cubic inches contain two sound wave, sound-direction-finder recording diaphragms, filing and reference system – analytical laboratory containing minute records of past events, three-dimensional optical system, spongy eyeballs filled with glutinous vitreous humor. The organ that tells £1 notes from tax demands by their reflected image on the inner membrane! Lacrimal glands provide the eye with a salty solution, reducing friction, washing away foreign matter, giving tunesmiths something to write about! The brain floats about like an overgrown walnut in glutinous cerebro-spinal fluid, all 49.6 oz. dull grey bewilderment, divided into four strange median sections: cerebrum, cerebellum, medulla oblongata, and if you're off to Studio 54 don't forget the pons varolii, it's the reflex centre for sneezing, masticating, swallowing, sucking, coughing, vomiting and winking. So, there's all this podgy, spurting, 98.6° blood, gristle – porous, spongy, blubbery, lolloping, sloshing, trickling, nerve-twitching, fluid, visceral, farting, gurgling, bladder-filling, heart-fluttering, excreting, salivating, meat moving about, and here's what bothers me: when I close my eyes – where do all the weird pictures come from?

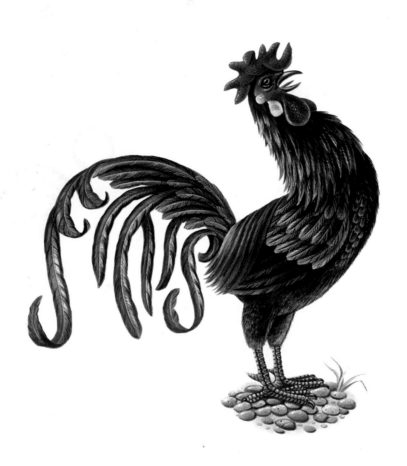